tukiliit

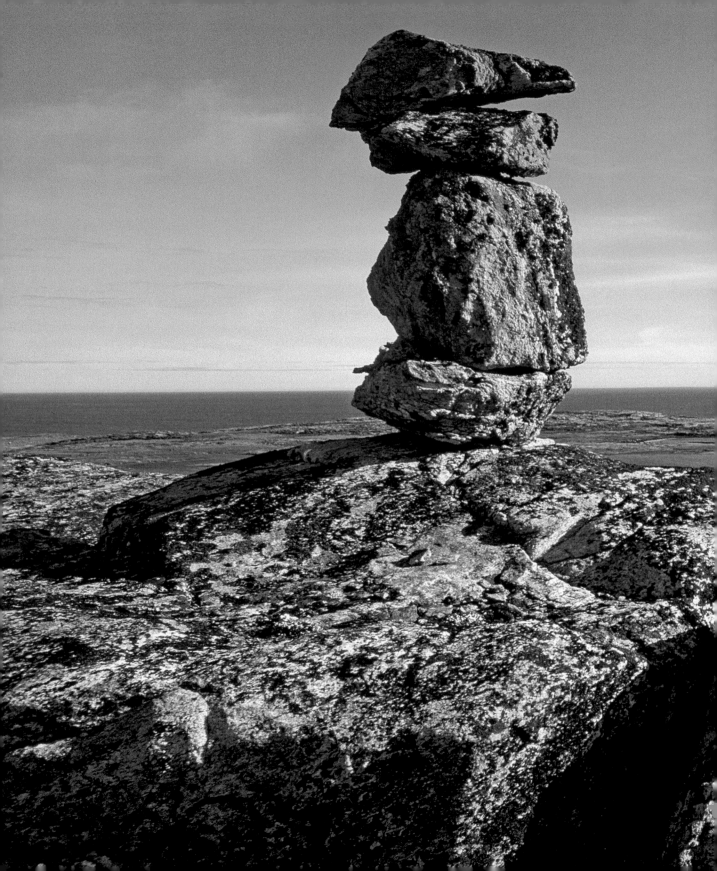

tukiliit

HE STONE PEOPLE WHO LIVE IN THE WIND

NORMAN HALLENDY

an introduction to inuksuit
and other stone figures of the north

 Douglas & McIntyre
D&M PUBLISHERS INC.
Vancouver/Toronto

University of Alaska Press
Fairbanks, Alaska
www.uaf.edu/uapress

sanngijualuit uqausiit

THE POWER OF WORDS

Tukilik (plural *tukiliit*) / any object that has meaning [Inuktitut]

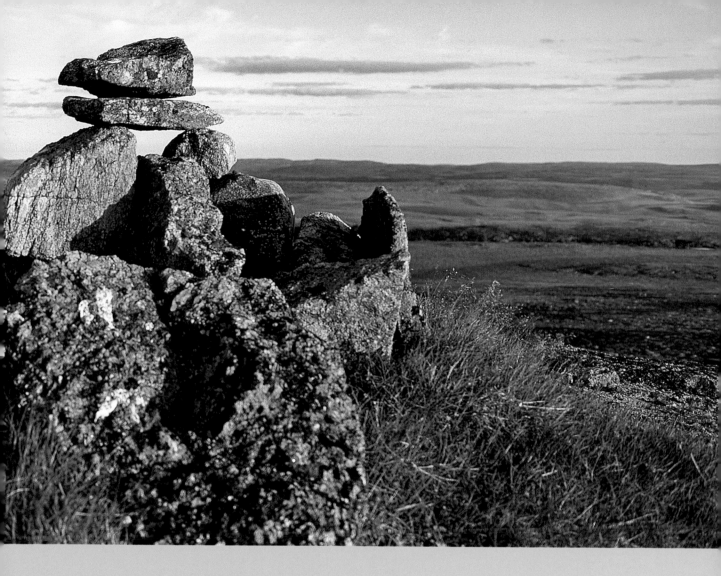

There was a time, now barely remembered, when it was the custom for Inuit to give a powerful word or string of words to another person as a gift, in the form of an incantation. It was believed that words presented in this way had magical powers that allowed the one who possessed them to see into things he or she had never seen or understood before.

In this spirit, the words and images which follow are a gift for you.

Text copyright © 2009 by Norman Hallendy

All photographs © 2009 by Norman Hallendy, except page 9 left © Dan Utting; page 9 above right © John Connor McMahon; page 11 © Sigurour Magnusson; page 57 © Peter Irniq; and pages 59 & 72 left © Department of National Defence (photo RE2005-0114-44A Cpl David McCord, Canadian Forces Joint Imagery Centre)

09 10 11 12 13 5 4 3 2 1

Douglas & McIntyre
A division of D&M Publishers Inc.
2323 Quebec Street, Suite 201
Vancouver, British Columbia V5T 4S7
www.dmpibooks.com

Published in the United States of America by:
University of Alaska Press
PO Box 756240
Fairbanks, Alaska 99775-6240
www.uaf.edu/uapress

Library and Archives Canada Cataloguing in Publication

Hallendy, Norman, 1932–
 Tukiliit : an introduction to inuksuit and other stone figures of the North / Norman Hallendy.

ISBN 978-1-55365-424-7

 1. Inuksuit. 2. Inuit—Canada.
3. Inuit—Canada—Material culture.
I. Title.

E99.E7H243 2009 305.897'12071
C2008-906171-3

Library of Congress Cataloging-in-Publication data is available upon request

Cover image: Inuksutuqaaluk, the ancient inuksuk at the sacred site of Inuksugalait, southwest Baffin Island, © 2009 by Norman Hallendy
Editing by Scott Steedman
Cover and text design by George Vaitkunas
Printed and bound in China by C&C Offset Printing Co. Ltd.
Printed on acid-free paper

Douglas & McIntyre gratefully acknowledges the financial support of the Canada Council for the Arts, the British Columbia Arts Council, the Province of British Columbia through the Book Publishing Tax Credit and the Government of Canada through the Book Publishing Industry Development Program (BPIDP) for its publishing activities.

Pages 2–3, A turaarut, an inuksuk which acts as a pointer. This example indicates the direction of the sea from a place inland from Shugba Bay, southwest Baffin.

Pages 4–5, An ancient inuksuk, possibly Paleoeskimo, midway between Kinngait (Cape Dorset) and the northernmost tip of Sikusiilaq (Foxe Peninsula).

CONTENTS

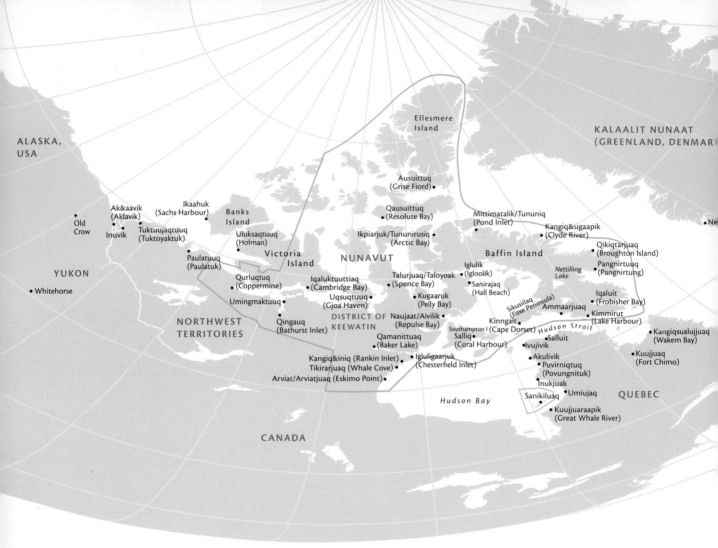

ALASKA,
USA

KALAALIT NUNAAT
(GREENLAND, DENMAR

Ellesmere
Island

Ausuittuq
(Grise Fiord)

Qausiuttuq
(Resolute Bay)

Mittimatalik/Tununiq
(Pond Inlet)

Kangiq&ugaapik
(Clyde River)

N

Old
Crow

Ak&aavik
(Aklavik)

Ikaahuk
(Sachs Harbour)

Banks
Island

Ikpiarjuk/Tununirusiq
(Arctic Bay)

Qikiqtarjuaq
(Broughton Island)

Inuvik

Tuktuujaqtuuq
(Tuktoyaktuk)

Uluksaqtuuq
(Holman)

Baffin Island

Pangnirtuuq
(Pangnirtung)

Paulatuuq
(Paulatuk)

Victoria
Island

NUNAVUT

Iglulik
(Igloolik)

Nettilling
Lake

YUKON

Qurluqtuq
(Coppermine)

Iqaluktuuttiaq
(Cambridge Bay)

Talurjuaq/Taloyoak
(Spence Bay)

Sanirajak
(Hall Beach)

Iqaluit
(Frobisher Bay)

Whitehorse

Umingmaktuuq

Uqsuqtuuq
(Gjoa Haven)

Kugaaruk
(Pelly Bay)

Sikusiilaq
(Foxe Peninsula)

Ammaarjuaq

Kimmirut
(Lake Harbour)

NORTHWEST
TERRITORIES

Qingauq
(Bathurst Inlet)

DISTRICT OF
KEEWATIN

Naujaat/Aivilik
(Repulse Bay)

Kinngait
(Cape Dorset)

Hudson Strait

Kangiqsualujjuaq
(Wakem Bay)

Qamanittuuq
(Baker Lake)

Southampton I

Salliq
(Coral Harbour)

Salluit

Kuujjuaq
(Fort Chimo)

Kangiq&iniq (Rankin Inlet)

Igluligaarjuk
(Chesterfield Inlet)

Ivujivik

Akulivik

Tikirarjuaq (Whale Cove)

Puvirniqtuq
(Povungnituk)

Arviat/Arviatjuaq (Eskimo Point)

Inukjuak

QUEBEC

Sanikiluaq

Umiujaq

Hudson Bay

Kuujjuaraapik
(Great Whale River)

CANADA

FOREWORD

Imagine for a moment that time does not exist. From a vantage point near the
top of the earth, you are staring down upon an ancient landscape spanning
the Old and New Worlds. It is a vista of indescribable beauty: jagged mountains,
endless plains, ragged coastlines, shifting deserts and brooding glaciers. The
human presence is barely discernible; the hunters, gatherers and herders who
wander these vast and varied expanses have left few traces upon them. But look
closely and you can discern the faint impression of a simple shelter or perhaps
a windswept grave. And across the land are stone objects which were essential in
their way to the people's survival.

left, What appears to be a simple stack of stones at Beas Kund, Himachal Pradesh, India, is in fact what the Tibetans call a *stupa*, or chorten. Though its form is elementary, this one is revered by Buddhists as highly as the ornate stupas found throughout the Buddhist world.

right top, North of Mongolia's Altai Mountains, on the road to Karakorum, stands this chorten, honoured by Buddhists to this day. Like the tunnilarviit of the Canadian Arctic, it is an object of veneration.

right below, High on a ridge on the Moapa reservation in Nevada, near the Valley of Fire, stand these lichen-encrusted stones, whose original names are now forgotten. Some marked Paiute trails which extended over a vast desert territory stretching from Oregon into Idaho and Utah and south to Arizona, Nevada and California.

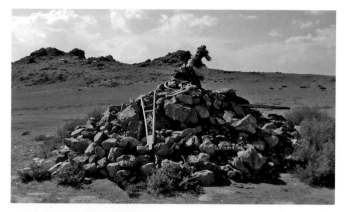

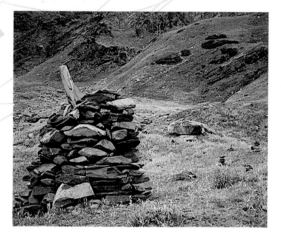

On a windswept mountain pass in India, you see a young monk standing beside a stone figure called a *chorten*, offering prayers to the Buddha. On an arid plain in a Nevada desert, you come upon an ancient *inuksuk*-like marker erected by a Moapa Indian. Far to the east, in Mongolia, stands a cairn-shaped pile of stones called an *ovoo*; if you look closely, you may see the weathered jawbone of a horse, a strand of blue silk bearing words to appease an angry spirit or the shattered pieces of a cellphone. Since the time of Chinggis Khan, travellers have stopped at these *ovoonuud* to leave gifts for the spirits. At the edge of Lake Baikal in Siberia stands a stone figure that, from a distance, resembles a person.

In the Faroe Islands, you are warned not to touch the *huldusteinur*, a huge stone in which the *Huldufólk*, or "hidden people," dwell.

Walking the ancient pathways of Iceland, you might come upon a large figure known as *Beinakerling*, the "bone woman." You may be the first person to visit this place since the day a lonely wanderer stopped here and wrote a poem on a piece of parchment, ending it with a passionate "I love you." Then he rolled his love poem up, slipped it into the hollow leg bone of a sheep and inserted it into his stone woman. Perhaps he was the one who constructed her—or she may have been standing there long before he passed that way.

Within this stone, called a huldusteinur, dwell the Huldufólk, the hidden people of the Faroe Islands. Woe to whoever dares disturb them, for the Huldufólk can wreak great havoc upon thoughtless humans. Their name in Inuktitut is *tarriasuit*, shadowy figures who can assume the shapes of humans.

This Beinakerling, or "bone woman," stands upon a windy hilltop at Sprengisandur, in Iceland. Like her sisters in other remote regions, she has been visited since ancient times by shepherds and travellers who have left love poems at her feet. More recently, she has been defiled by the occasional ribald or obscene message.

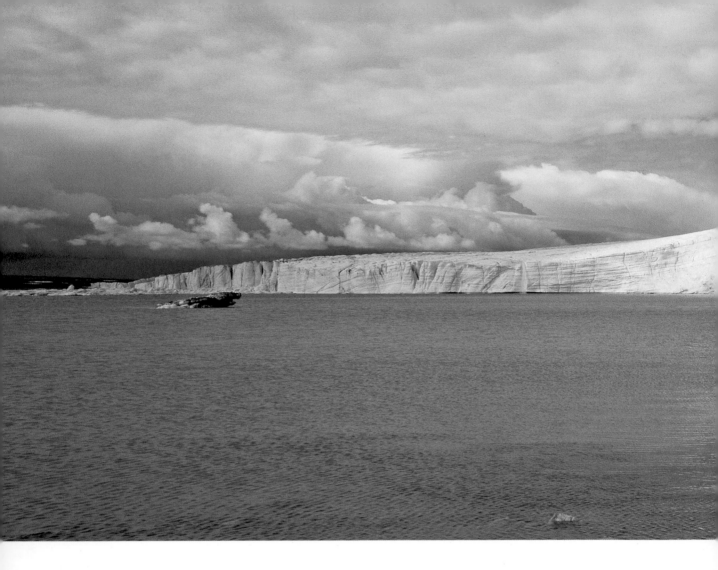

Far to the north is a place as mythical as the name she was given by the ancient Greeks: *Arktos*, meaning "bear" (after the constellation Ursa Major, the "Great Bear" that dances in the northern sky). Arktos eventually became "Arctic" in the languages of the southerners. But the Inuit, who have lived there for countless generations, have many other names for their home, including *Nunanak* ("a lovely, dear land"), *Nunatsiaq* ("the beautiful land"), *Nunatiavaluk* ("a bountiful and beautiful land"), *Nunaga* ("my land, my country") and *Nunanaraja* ("the land which remains in my heart"). More recently, a part of Nunatsiaq has been declared a self-governing territory of Canada under the name *Nunavut* ("our land").

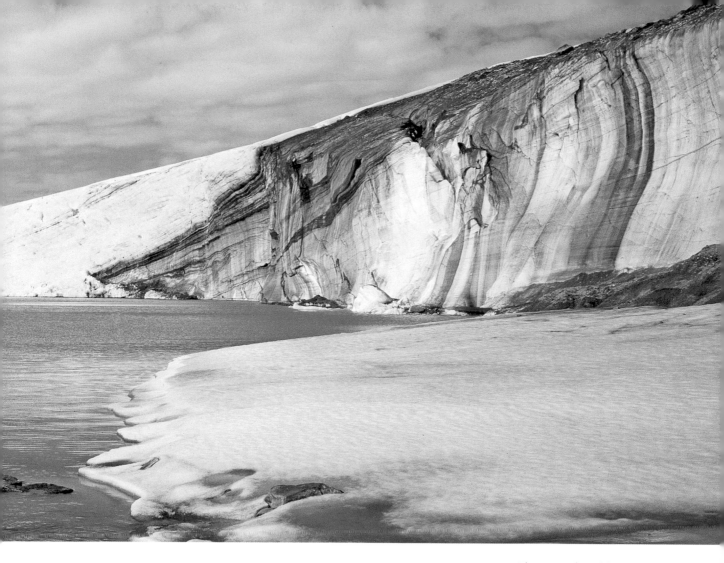

The western face of the Barnes Ice Cap, central Baffin Island. Some twenty thousand years old, the ice sheet may have once reached as far south as Kansas.

Whatever her name, Nunatsiaq is one of the youngest ecosystems on this planet and one of the last great wildlife refuges on Earth. Her vast area of some two million square kilometres covers one-fifth of Canada. Here too, for countless generations, the people who have traversed her vast expanses have placed figures of stone upon her. This book tells the story of those remarkable people and the silent messengers that have been part of their material culture for many centuries. Our *tukisiuti*—our path to understanding— of inuksuit and other stone figures of the Arctic begins here.

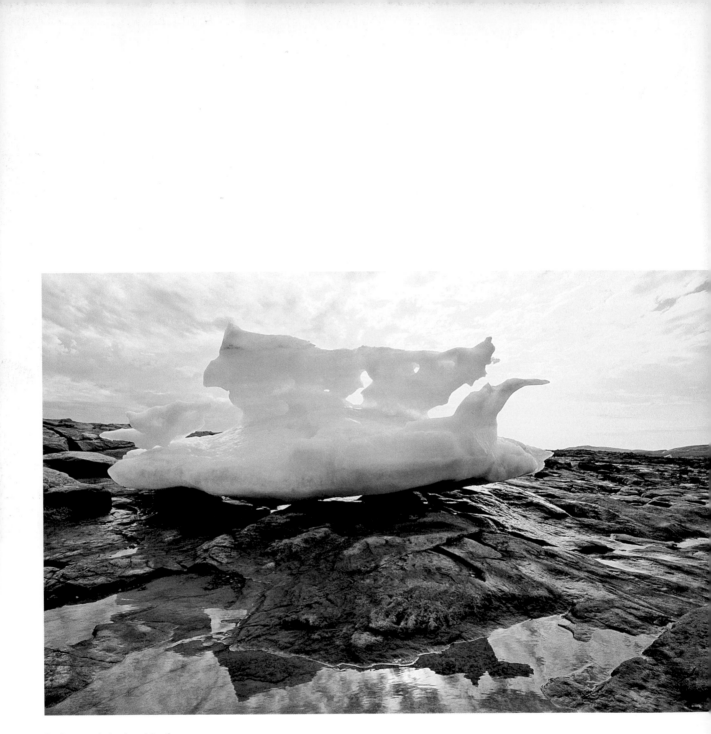

Sea ice stranded at low tide often
assumes fantastic shapes as it melts.

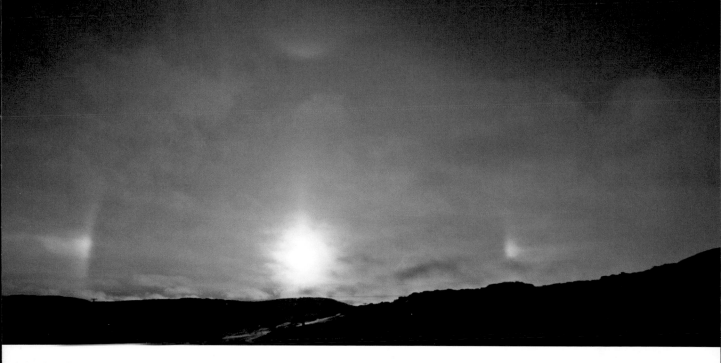

Perihelia, also called Arctic sun dogs, are fascinating phenomena. They are often created when sunlight is refracted through very small ice crystals, known as "diamond dust," suspended in the air.

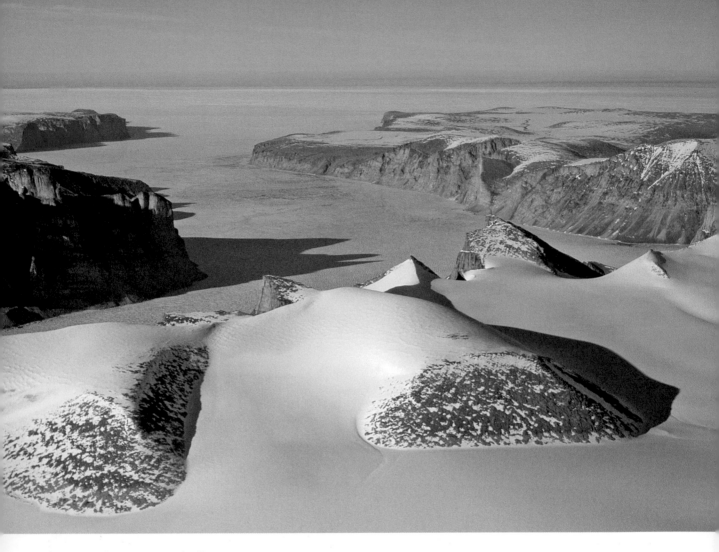

The spectacular eastern coast of Baffin
Island with its glaciers and great fjords.

Akshayuk Pass, in Auyuittuq National Park on southeast Baffin Island, is one hundred kilometres long. The dramatic forms were carved by an ancient glacier seeking its way to the sea.

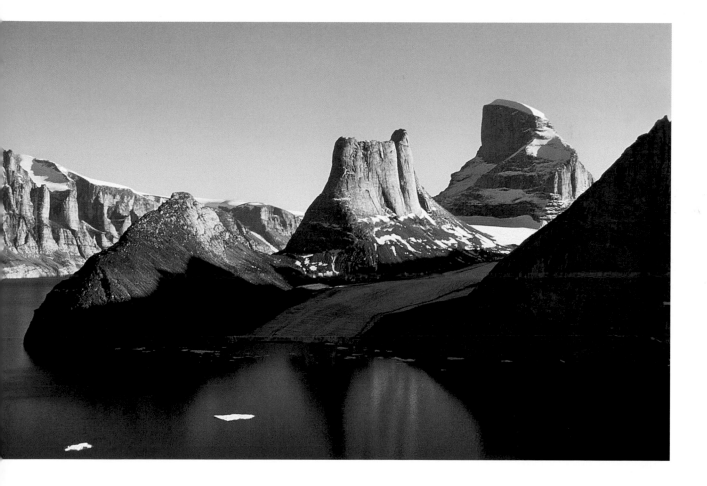

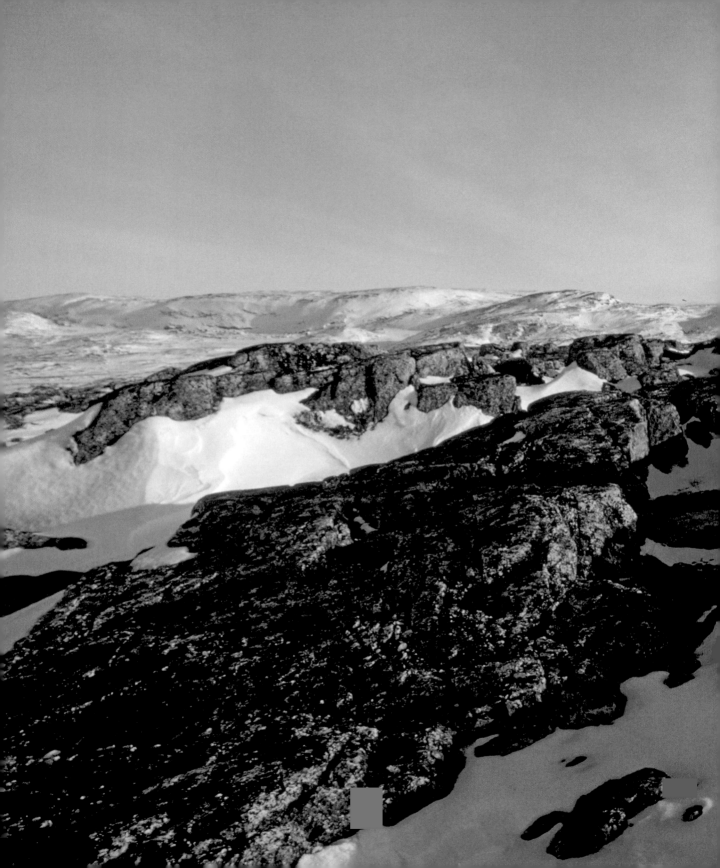

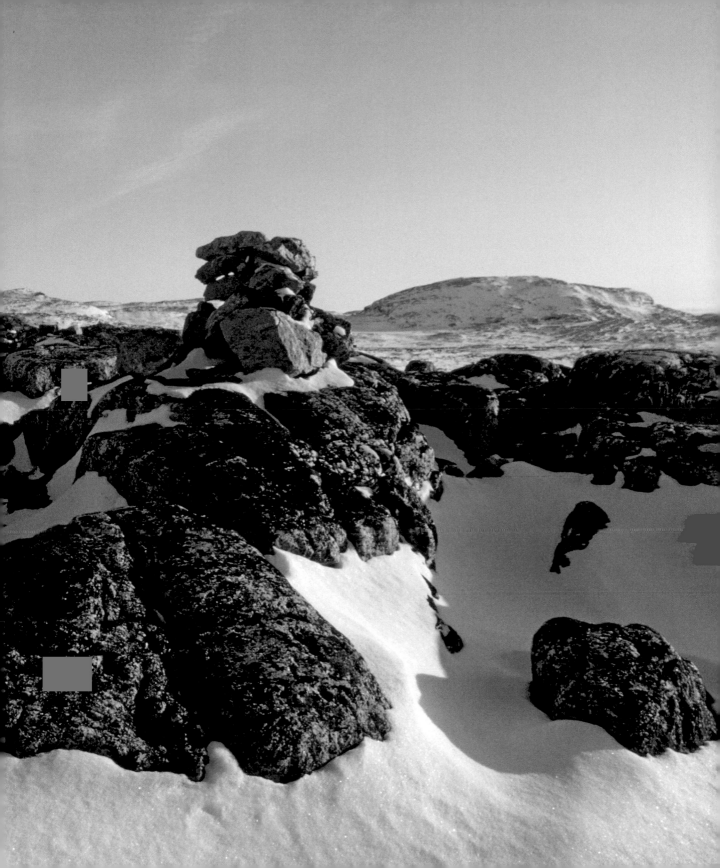

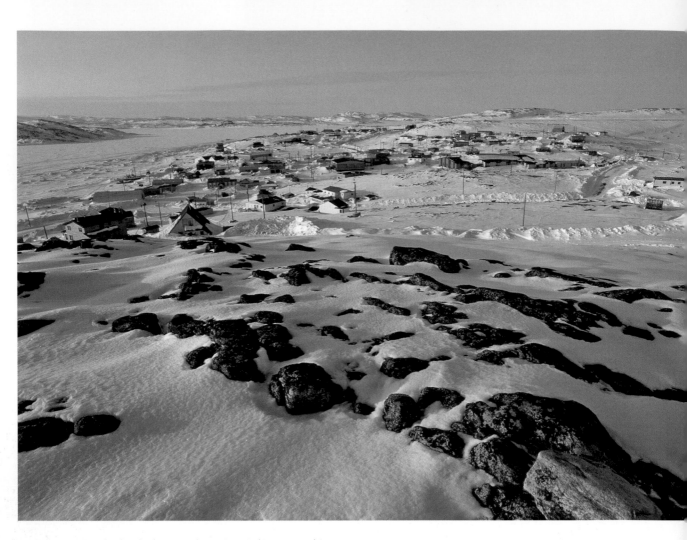

previous pages, An inland inuksuk that directs travellers towards the settlement of Kinngait (Cape Dorset).

above, Kinngait (Cape Dorset) in southwest Baffin Island. With a population of more than 1,350, this is one of the most prolific art-producing communities in the entire Arctic. Traces of human habitation found in the area reach back at least three thousand years.

Beholding a sight such as this one during a journey to the coast, the elder Osuitok described it as "a mountain pushing against mist."

Intense cold creates beautiful
designs in sea ice, which can
grow to three metres or more in
thickness.

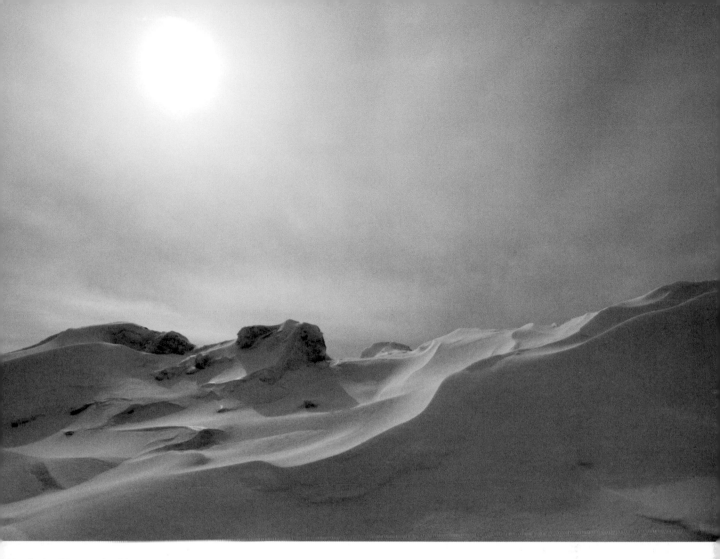

March, the elders say that "the
un is still without a reality." After
onths of total darkness, it may be
hining but it brings little heat.

previous pages, Standing at the western edge of Sikusiilaq (Foxe Peninsula) reminds one of the expression *sarqarittukuurgunga*, which describes travels through places of vast horizons.

below, The Barnes Ice Cap, central Baffin Island, contains some of the oldest remaining ice in Canada. Once up to three kilometres thick, it is rapidly melting.

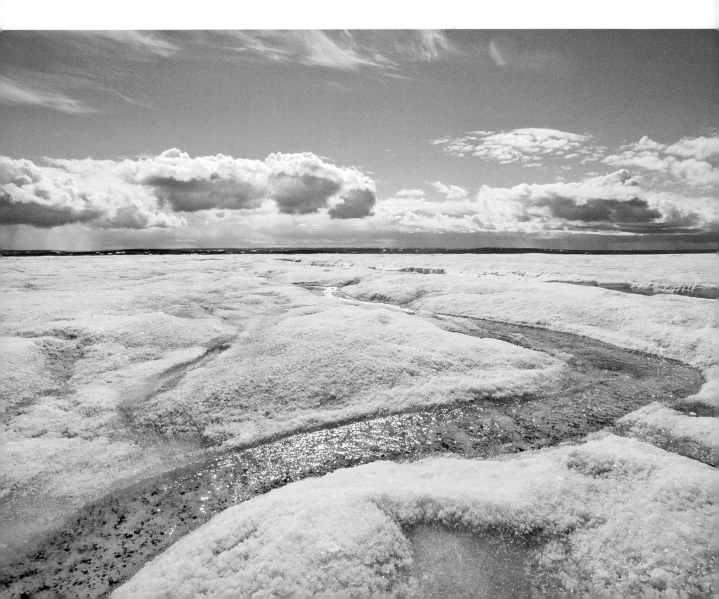

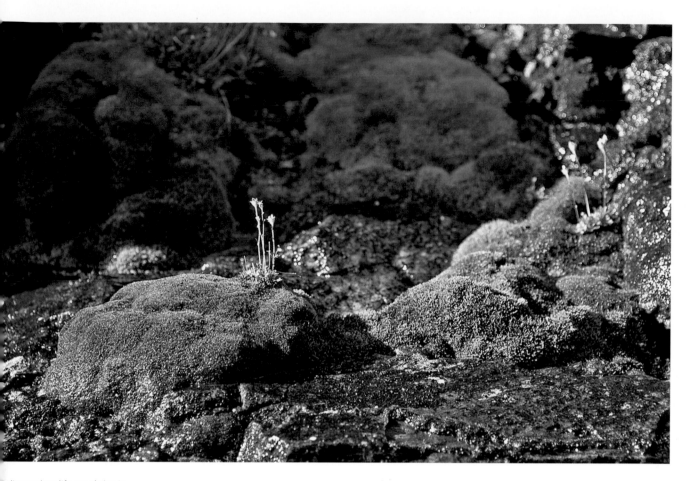

Delicate plant life can thrive in
an area no larger than the space
between your outstretched arms,
as long as there is a bit of shelter
and a constant source of moisture.

innunguaq

THE LIKENESS OF A PERSON

The Inuit have many words to describe the various stone figures of the Arctic. The best known is *inuksuk* (plural *inuksuit)*, which means "that which acts in the capacity of a human." Like the English word "tree," which is used for a great variety of plants of all shapes and sizes, *inuksuk* is a general term that is often applied to all stone figures. But not all are inuksuit, as we are about to discover. A better general word is *tukilik* (plural *tukiliit)*, literally "that which has meaning." In Inuktitut, this refers to all meaningful stone objects, whatever or wherever they may be, anywhere in the world.

 Innunguaq refers to an image or object in the likeness of a person. The innunguaq is not an inuksuk. It may be a doll, a small stone shaped like a human or a large

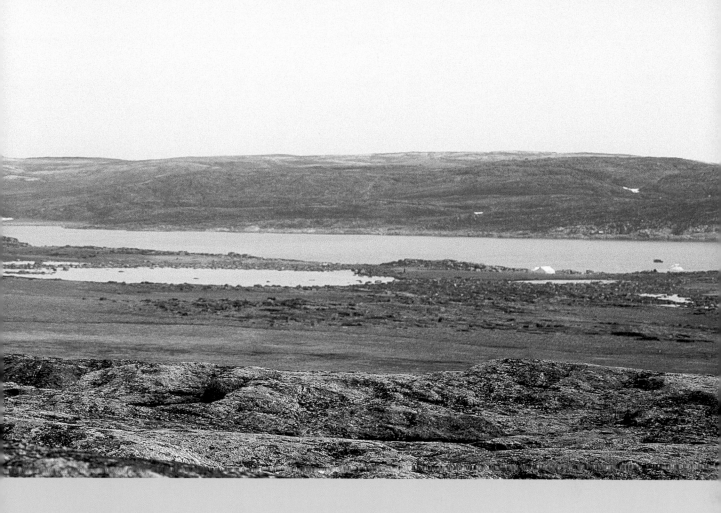

figure constructed of stones and placed upon the landscape. The innunguaq had limited but interesting functions. During the nineteenth century, Inuit who lived in areas visited by Scottish whalers would construct *innunguait* in the spring to let the whalers know Inuit were nearby. Often the whalers took local Inuit hunters aboard ship to act as pilots through the shoal-infested waters of the Arctic coast.

In more recent times, an inuk (Inuktitut for "person") might erect an innunguaq at a place he loved dearly or, more rarely, as a memorial to a cherished person. In the days of bows and arrows, young hunters made innunguait out of snow to use as targets. Shamans also made innunguait from snow and other

It is not an innunguaq, but from a distance this inuksuk in Sikusiilaq (Foxe Peninsula) looks like a human standing upon a hilltop.

This simple little innunguaq, barely
a metre high and created from just
few stones, welcomes those who
travel by sea to Kinngait (Cape Dors

materials at hand, though their purpose was more sinister: like voodoo figures, the innunguait were likenesses of specific people, which the shaman then cursed. The Inuit believed these actions could cause great harm, perhaps even death.

I have heard told that many years ago, a group of Inuit who lived on Little Diomede Island, in the Bering Sea, wanted to protect themselves from raiders who lived on Big Diomede Island. They constructed several innunguait which could be seen from a great distance. They then covered the innunguait in skins and gave them weapons to hold so that they would look like humans ready for battle.

If you ask Inuit in the central Arctic how long their people have been constructing innunguait, they often answer, "Before we can remember." Pose the same question to Inuit in the eastern Arctic and they often reply, "Most were built when the *arvaniaqtuiqqaaniqpaaminiit*, the first whalers, came to our land."

In recent times, the innunguaq has became known as the inuksuk, which it certainly is not. This imitation of a person has become an Arctic icon. Southern entrepreneurs have adopted its distinctive silhouette and used it in a myriad of logos advertising everything from beer to the Vancouver 2010 Winter Olympics. Innunguait have been constructed in airports, embassies and other Canadian institutions at home and abroad. Perhaps the most touching innunguaq is the one that stands in Kandahar, Afghanistan, to honour Canadian soldiers, and their comrades in the other international armed forces, who have lost their lives in battle there.

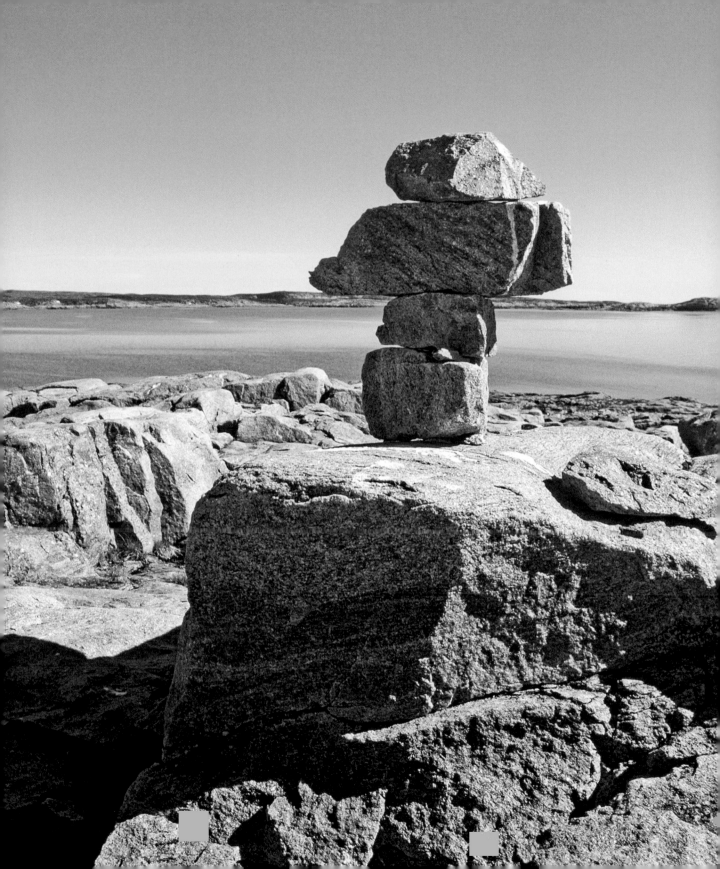

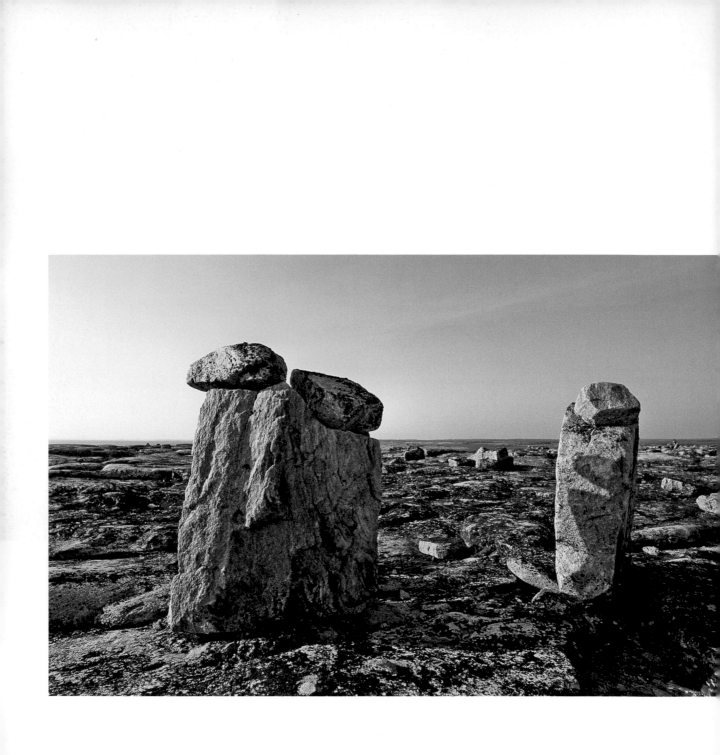

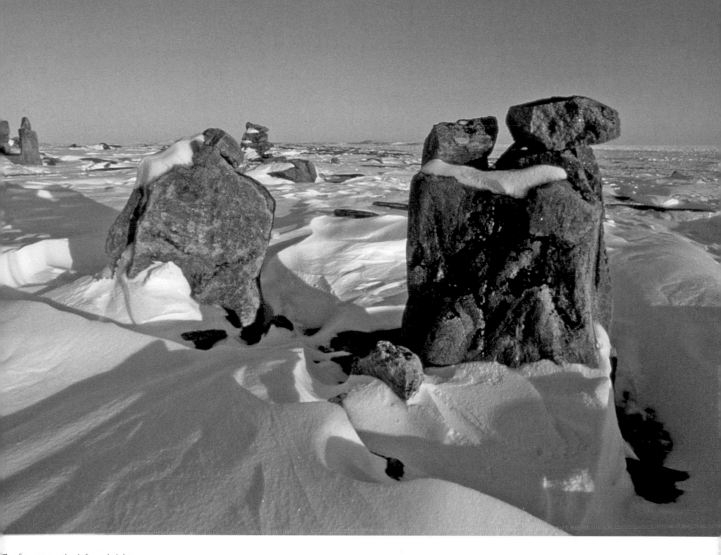

The figures on the left and right are the same inuksuk in different seasons. It is one of about one hundred figures standing at Inuksugalait, on the southwest Baffin coast. Snowfall often transforms the appearance of this single inuksuk into two people in an embrace.

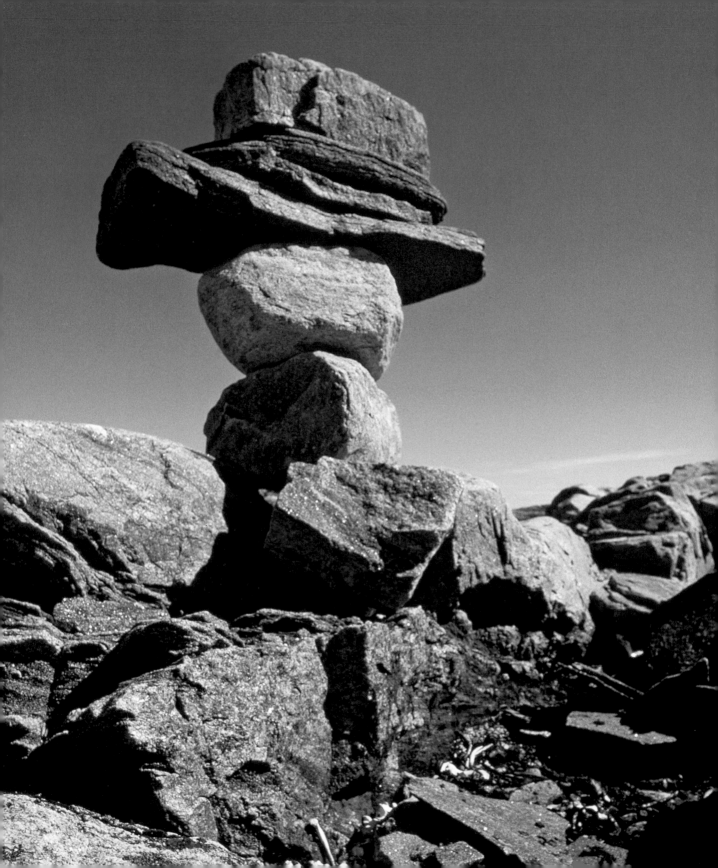

left, An innunguaq marking the place on an island where old women were left for brief periods during the spring hunt.

below, An ancient innunguaq at Itiliarjuk.

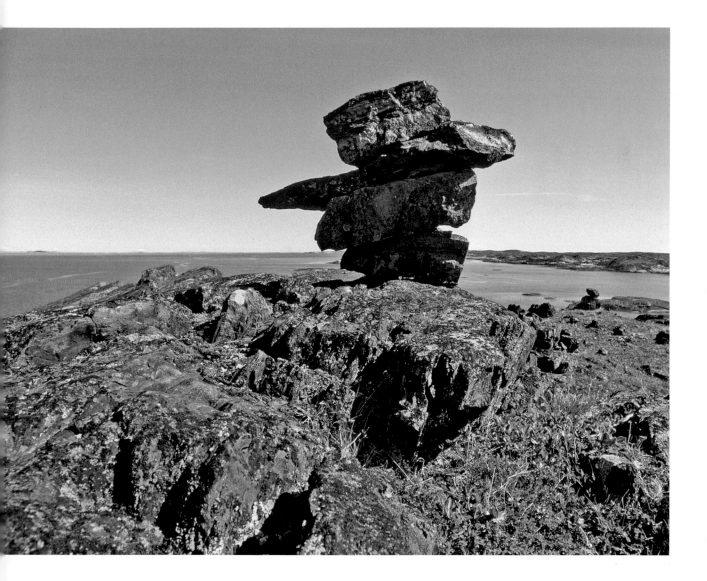

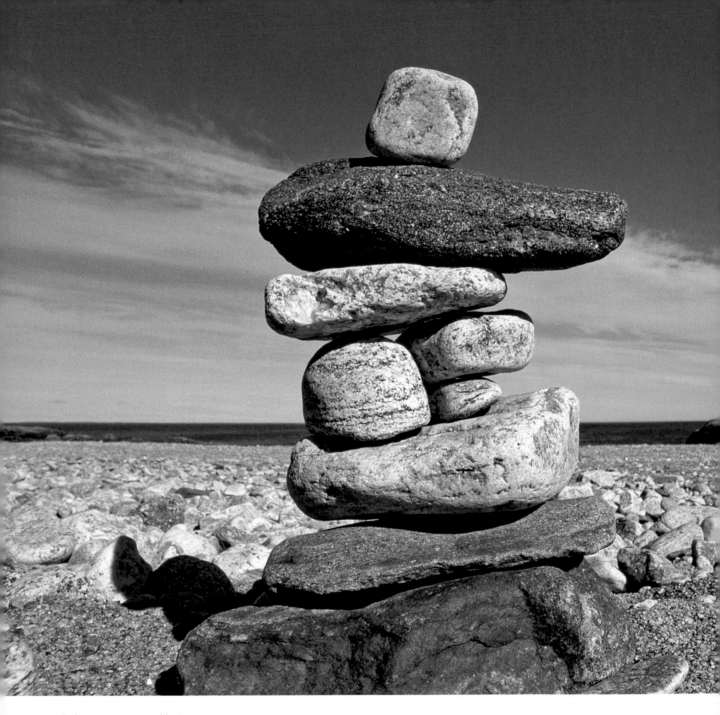

A little innunguaq created by a
child on a beach at Aupaluktuk,
near Kinngait (Cape Dorset).

top, Three distinct innunguait. Left to right: an innunguaq worn as a talisman; a small wooden innunguaq made for a child as a plaything; and a natural stone in the shape of an infant, cherished by its owner because "it came from the land."

bottom, Various innunguait, many carved by the children of famous Kinngait (Cape Dorset) artists. These innunguait are far superior to the commercial figures produced en masse by non-Inuit in the south.

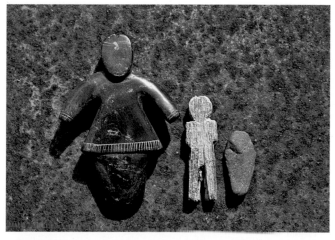

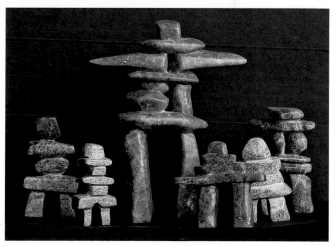

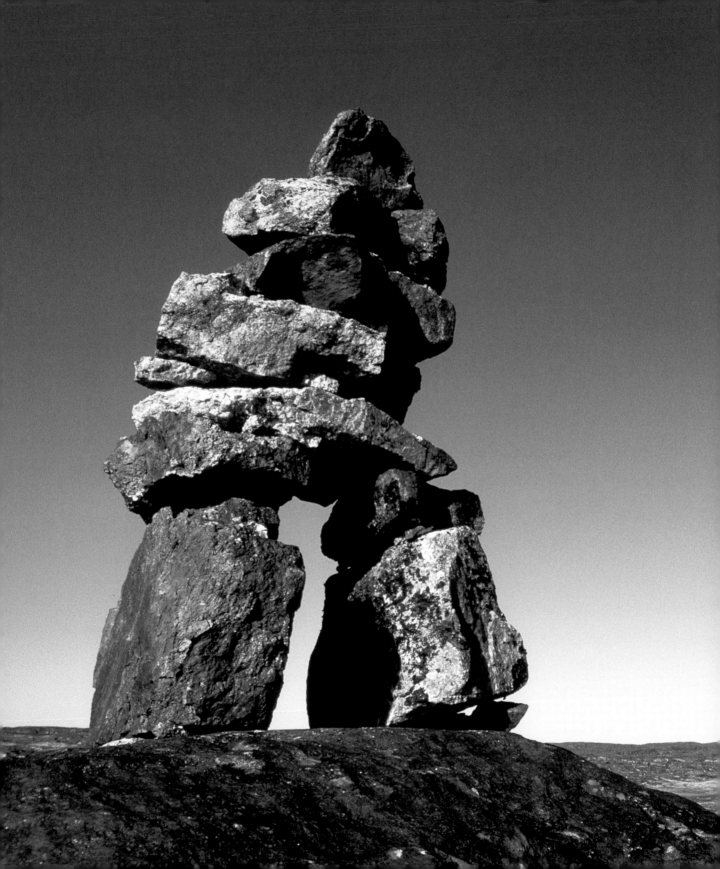

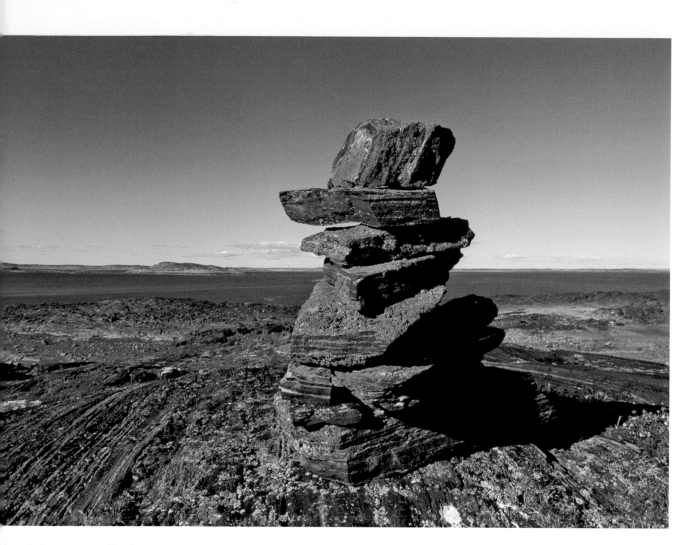

bove, An innunguaq marking the
~~v~~ay inland, southwest Baffin Island.

~~f~~t, An innunguaq marking the site
~~f~~ an ancient camp near Taliqruak,
~~h~~e place "shaped like the flipper of
~~~~ whale."

# sakkabluniit

## STONE OBJECTS IMBUED WITH POWER

*Sakkabluniit* is an ancient term referring to special stones or stone figures. Though they often look like inuksuit, they are not: they are a family of figures related to some spiritual entity, expression or place. One of the most revered of these arcane figures is the *angaku'habvik*.

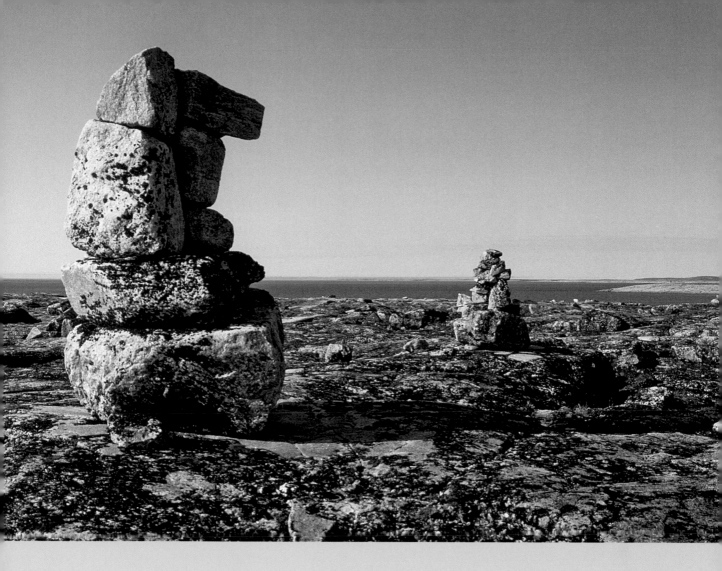

The angaku'habvik, or *angakkururvik*, is both an object and a place. Shamans were initiated where these stone structures stood, making these sites among the most respected places on the metaphysical landscape.

A *tunillarvik*, or *tunirrsirvik*, is a single stone believed to provide healing and protection to those who venerate it and leave it gifts.

A *tupqujaq* takes the form of a doorway, through which the shaman passes into the spirit world.

A *kattaq* is a simple entrance constructed of two stacks of stones about waist high, the gateway to a place of respect where traditional rites were performed.

Amid the many inuksuit at Inuksugalait are a few of special interest. Some stone figures were placed where a powerful event occurred: for example, at the place where an *angakok* ("shaman") received his or her *angakkua* ("enlightenment").

*Ujaraqtalik titirturvigisimajumik* are natural formations. Though not arranged or modified by any human, these stones bear strange markings suggesting some supernatural influence.

*Nunaupmannia* are round white stones that look like goose eggs. The Inuit once believed they were "Earth eggs," from which rare white caribou were born.

*Patiujaq* is white quartz. When placed on a grave, it is transformed in the beholder's mind into a spiritual object known as a *qaummaqquti*, a manifestation of the *innua* ("life force") of the deceased as he or she travels through the sky.

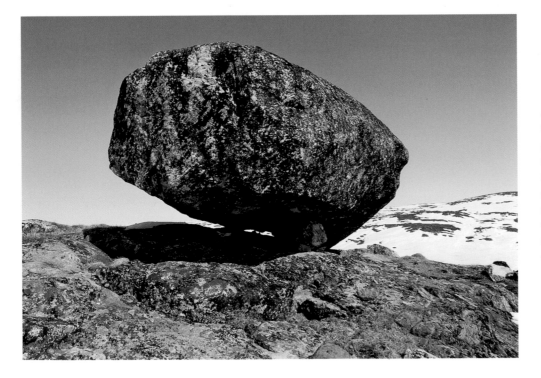

A perched or erratic boulder is a natural occurrence, left when a glacier deposits a large rock upon a bed of smaller stones. Eventually all the smaller stones except three are washed away, creating a most unusual sight. These *etigaseemaute* were revered by the Inummariit, the Inuit who lived in the traditional manner.

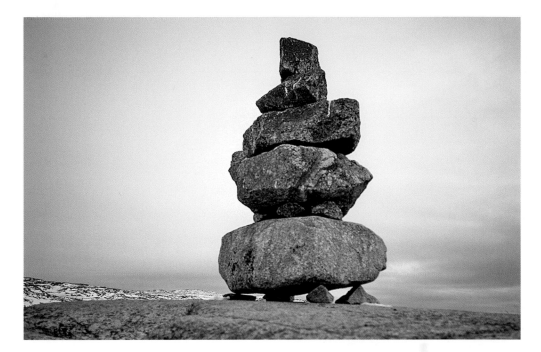

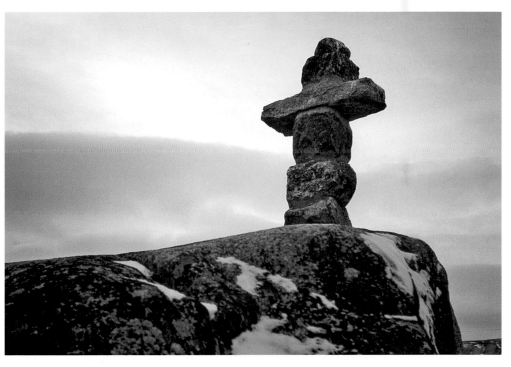

The figure above, atop a ridge at Kugaaruk (Pelly Bay), is a contemporary inuksuk constructed as if it were an integral part of an etigaseemaute. The figure below, which dominates the Catholic cemetery at Kugaaruk, fuses an innunguaq with a Christian cross. This appropriation of the innunguaq shape by some missionaries is understandable. However, elders throughout the Arctic insist that the innunguait existed long before the arrival of those "who speak a lot"—the missionaries.

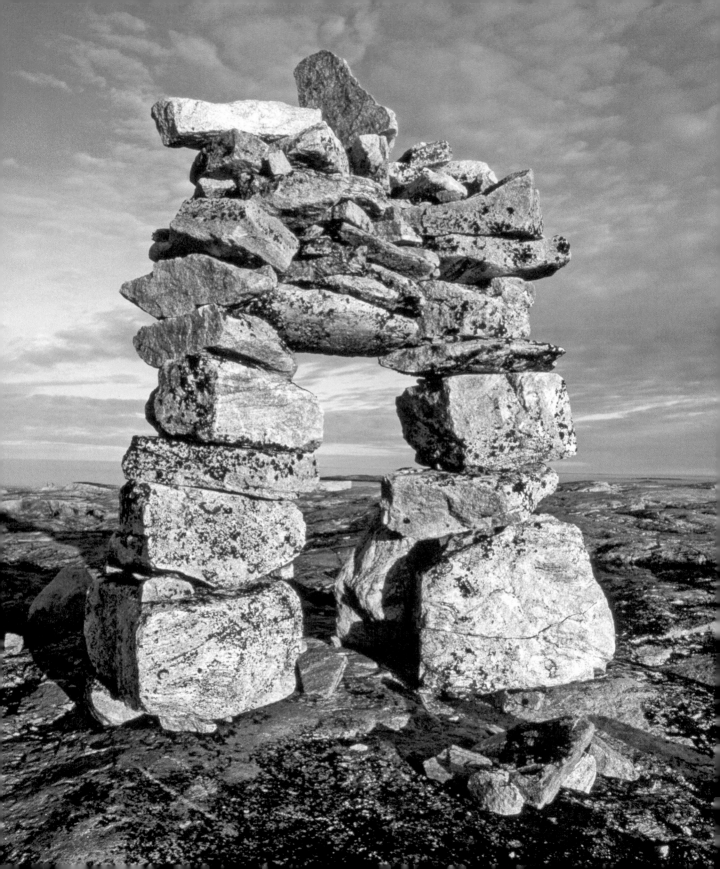

*eft,* The tupqujaq was the doorway that the angakok ("shaman") passed through into the world of spirits. Though most Inuit are now devout Christians, they still respect such ancient spiritual objects.

*below,* A tunillarvik, also called a tunirrsirvik, is a single stone believed to provide healing and protection to those who venerate it and leave it gifts.

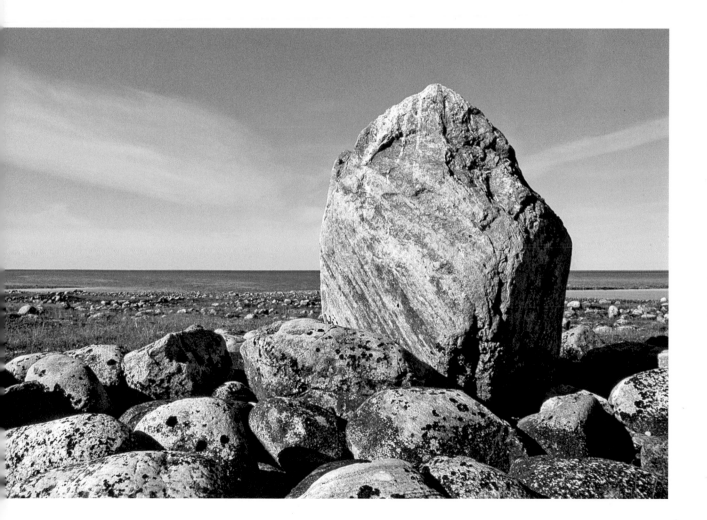

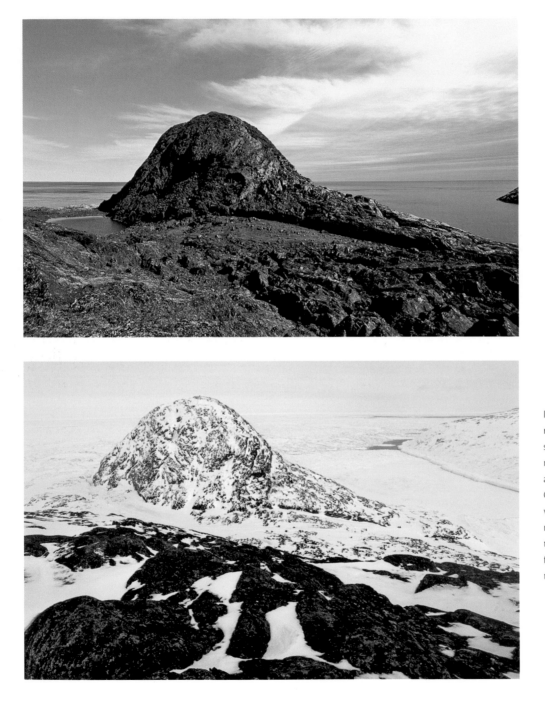

Igaqjuak was one of the most revered ceremonial sites in southwest Baffin Island. Its name means "the great fireplace," and it also had a hidden name, Qujaligiaqtubic, "the place from where one returns to Earth refreshed." An imposing site at any time of year, its rich and vibrant field of spring wildflowers attests to generations of feasting.

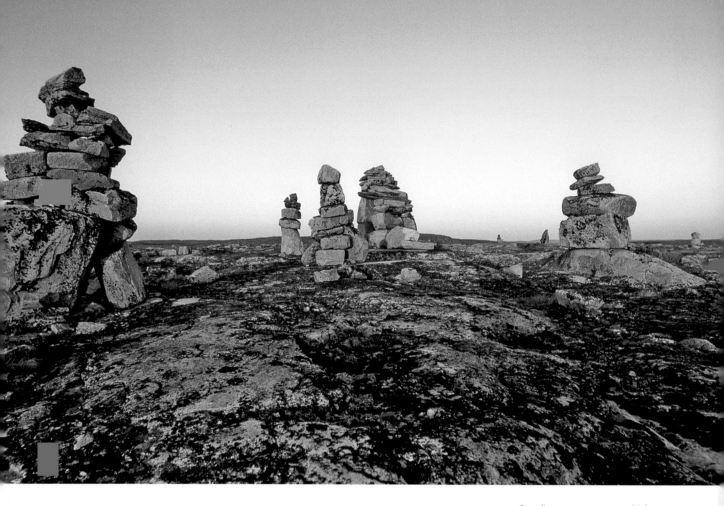

Standing over two metres high, the inuksukjuaq on the left dominates all the other inuksuit at Inuksugalait.

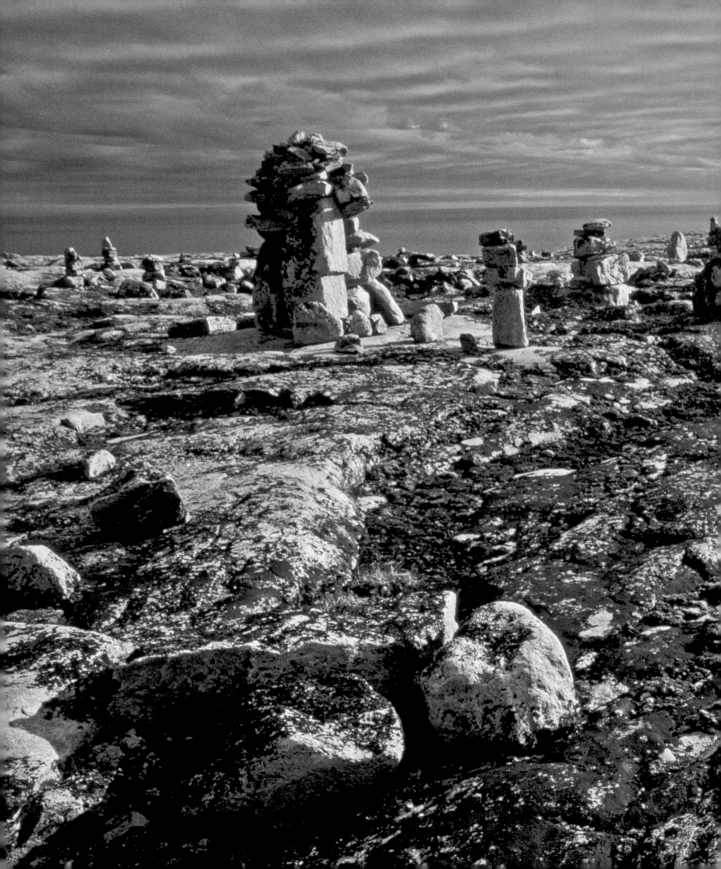

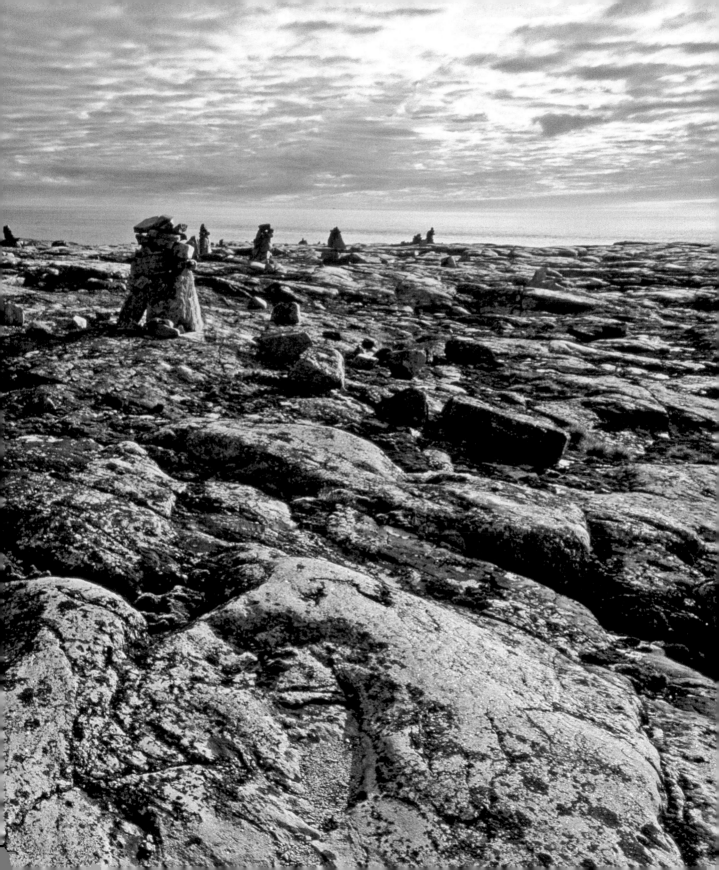

*previous pages*, Inuksugalait is one of the most impressive sites on the entire coast of southwest Baffin. None of the elders alive today know the answers to questions like who built the estimated two hundred inuksuit, why they chose this site and what purpose the site served. No two inuksuit here are alike, and much speculation surrounds the place.

*below,* One of the only things elders remember about Inuksugalait is that certain inuksuk-like figures, such as this *inuksuk anirniqtalik*, contained a spirit and should never be touched.

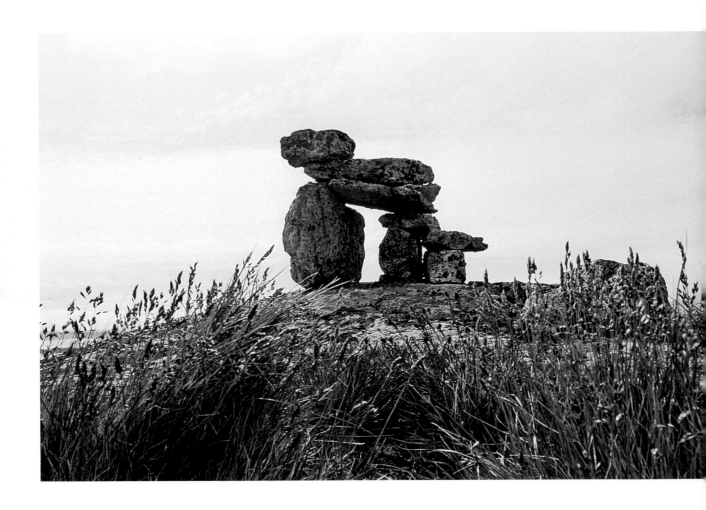

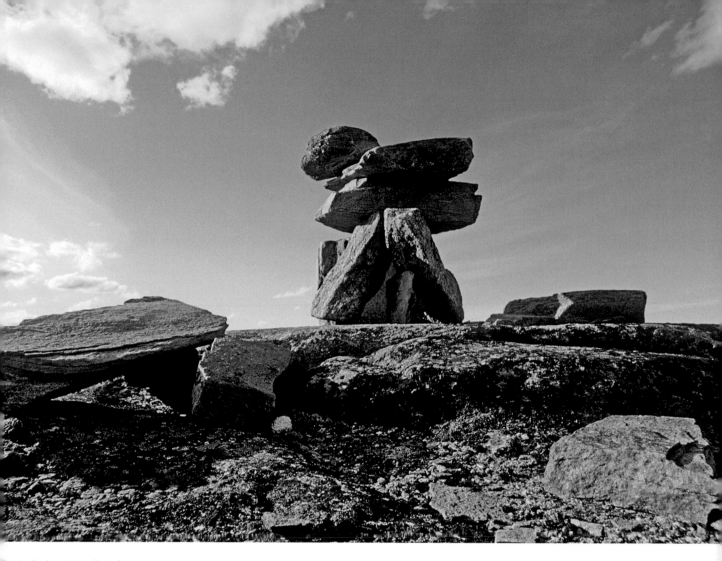

his inuksuk anirniqtalik in the
keness of a raven is perched on
hill near Kangisurituq (Andrew
ordon Bay), overlooking the
lands where the *Tunniit*, "the
ncient ones," lived.

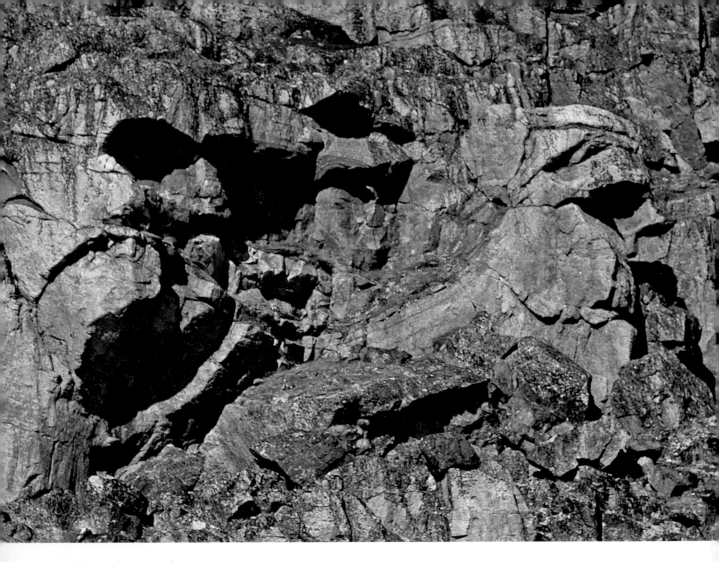

Near Kiaktu, in the Kinngait (Cape Dorset) area, is a place of graves. As the sun passes over a cliff sheltering the site, strange, grotesque figures appear to loom out of the cliff face.

This remarkable site is at Aupaluktuk, near Kinngait (Cape Dorset). There is evidence of much past activity in the surrounding area, except at the face of the cliff. The Inuit believed that the *ijirait*, caribou spirits that could behave like humans, lived here.

# inuksuk upigijaugialik

## AN INUKSUK THAT MUST BE VENERATED

Some inuksuit were memorials. These *inuksuit upigijaugialait* mark the place where some tragedy occurred or a loved one died. Some were constructed to receive the spirit of the dead and help it on its journey homewards.

Towards the end of winter in 1940, two camps of Inuit fought a terrible battle in the Kangisurituq (Andrew Gordon Bay) area on Baffin Island, near Kinngait (Cape Dorset). All the men who had come from a distant camp were killed, and their bodies were dumped on a small island known to this day as *Iluvirqtuq*, the place of graves. Rather than allowing the homeless spirits of the vanquished to wander about the islands, the victors erected an inuksuk for each dead soul. Some

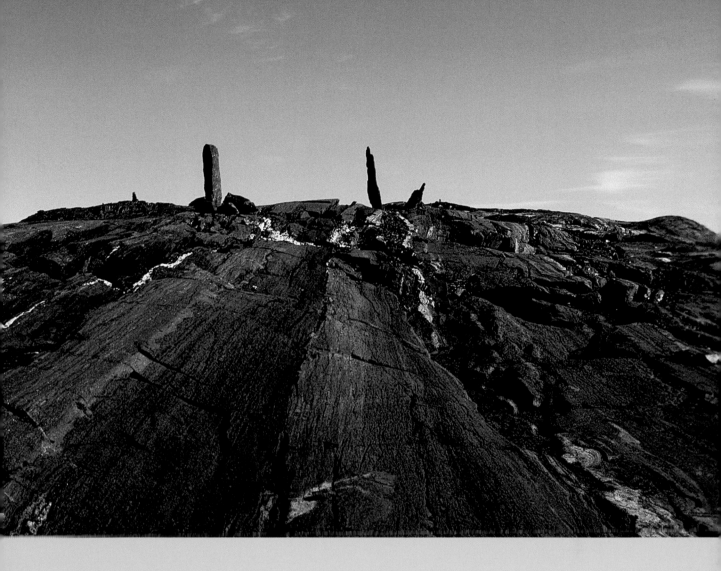

of these inuksuit upigijaugialait can still be seen, standing like shadowy figures on the windswept ridge at Itiliarjuk, at the entrance to the bay.

The famous Arctic explorer Knud Rasmussen documented another tragic tale he heard from an Inuk named Manelaq in 1930. In Rasmussen's words:

> Once all the men at Kamigluk went hunting for caribou and only the women were left. The men urged them not to fish from the edge of the ice, but the women did so just the same. Suddenly the ice went adrift and they dared not jump ashore; there was only one who took the risk, and was saved. All the others went out to sea and were lost. So pitiful were their cries and screams out on the drifting ice that from a distance it sounded like the howls of terrified foxes.

When seen from a distance, these single, upright stones conjure an image of phantoms on a spectral landscape. They mark the entrance to a dangerous passage between Itiliarjuk and Kangisurituq (Andrew Gordon Bay).

But when the men came home they sorrowed so deeply over the loss of their women that they built *cairns* [inuksuit] up on the shore, just as many *cairns* as there were women lost. They did this because they wanted the souls of the drowned women to be on dry land and not out in the wet sea.

Inuksuit upigijaugialait and similar figures have been created as memorials to honour the fallen in battle in such places as Juno Beach and Kandahar. One at Juno Beach is dedicated to the brave Inuit soldiers who died while storming the beach during the D-Day landings of June 1944. My friend Peter Irniq constructed this memorial close to the Juno Beach Centre (right). It has a "window" at the top, facing Canada. This has a dual purpose: to allow the spirits of the fallen to look in the direction of Nunatsiaq, their beautiful land, and to allow those back home in Canada to look towards the sacred ground where their sons and fathers died.

Far to the east of France, at the crossroads of Southern and Central Asia, is a place as remote as any in Canada's High Arctic. Here, too, the scorching winds of summer are replaced by the bitter cold of winter, and here, too, countless lives have been lost in a succession of wars, reaching back to at least the fourth century BC. One of the world's greatest warriors, Alexander the Great, founded a city here that would later be called "Qandahar," or Kandahar.

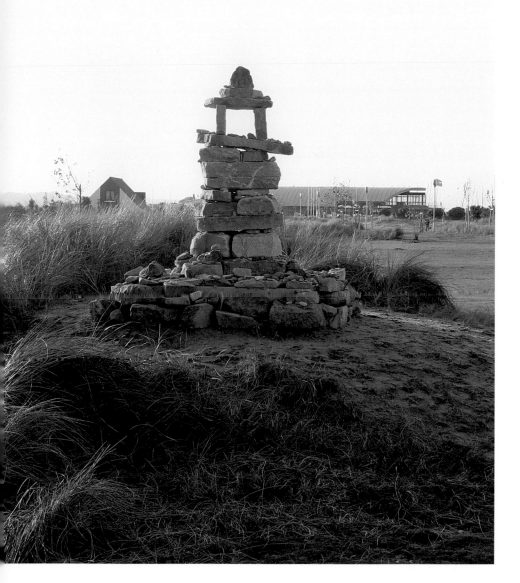

At Juno Beach in Normandy, France, stands this niungvaliruluk, an inuksuk with a window, dedicated to the Inuit who died during World War II. Constructed by Peter Irniq, it is one of two memorials at Bernières-sur-Mer.

Today, a little stone figure much like an inuksuk upigijaugialik stands near the Kandahar Airfield. A band of Canadian infantrymen and engineers fashioned it from small pieces of slate found lying about their military base and larger pieces taken from a nearby farm. The soldiers reported that, at first, the farmer resented their intrusion, but when they told him why they wanted his stones, he told them to take whatever they needed.

The innunguaq was originally built to honour four comrades—Corporal Ainsworth Dyer, Sergeant Marc Leger and privates Richard Green and Nathan Smith—killed by friendly fire in the spring of 2002. It has since become a memorial to all of those killed or wounded during the campaign in Afghanistan. One of the plaques at its base reads:

### INUKSUK

The term inuksuk means, "to act in the capacity of a human"
Among the many practical functions, they were employed as hunting and
navigational aides, often showing the
direction towards a food supply or home.
In addition to their earthly functions, certain inuksuit had
spiritual connotations and were objects of veneration,
often marking the threshold of the spiritual landscape,
or in other words Sacred Ground.
We hope that this place will remain sacred and that the
spirits of our fallen comrades will find their way home to peace and rest

Standing at the Kandahar Airfield in Afghanistan is a unique innunguaq. It was constructed by members of the 3rd Battalion of Princess Patricia's Canadian Light Infantry as a memorial to four Canadians killed while serving their country.

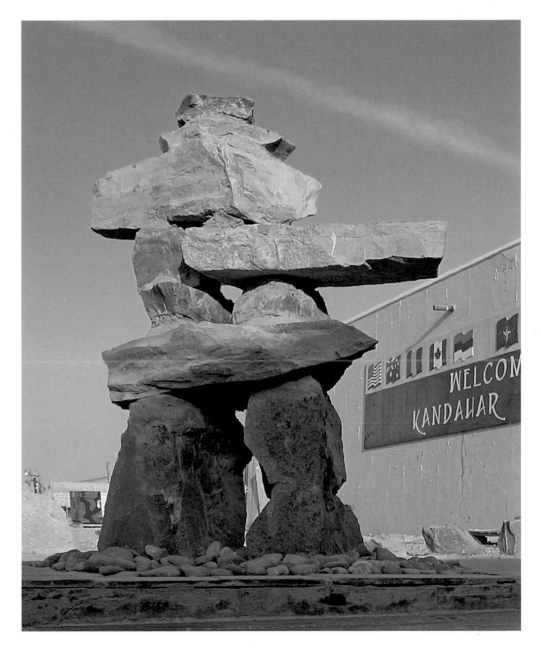

# inuksuk

## THAT WHICH ACTS IN THE CAPACITY OF A HUMAN

Unlike an innunguaq, which resembles a person, an inuksuk is a stone object built by the Inuit to serve in the capacity of a person. In other words, inuksuit act as helpers. They have many functions, for example:

They acted as indicators, showing:

- the depth of the snow
- places where food, supplies or articles had been cached
- safe or dangerous crossing places
- the deep or shallow side of a river
- a spot where ice was dangerous in spring
- the direction, or change of direction, of a hunter
- the spot where caribou crossed a river or lake
- where fish spawned

A beautiful, contemporary inuksuk at Tellik Inlet near Kinngait (Cape Dorset).

- a good spot for hunting seals, walruses or whales
- a good fishing spot
- a good spot for egg gathering
- hauling-out places for seals, walruses or whales
- landing sites for *umian* and *qajait* (open boats and kayaks)
- the furthest limit of one's journey
- places where important resources such as soapstone, chert, pyrites, carbide or quartz crystals could be found

They aided in navigation, revealing:
- the best route home (not necessarily the shortest)
- the direction of the mainland from a distant island
- the direction of a significant place inland
- the direction of a significant place below the horizon
- major transition points between water routes and inland routes
- places to go to find game

They were hunters' helpers, used as:
- drift fences, to guide caribou towards hunters
- direction changers, to move caribou away from a regular route
- sound makers, to frighten caribou towards hunters
- dummies which looked like seated human figures
- bird decoys

Some inuksuit had an astronomical significance, such as:
- pointing to the pole star
- pointing to the midwinter moon

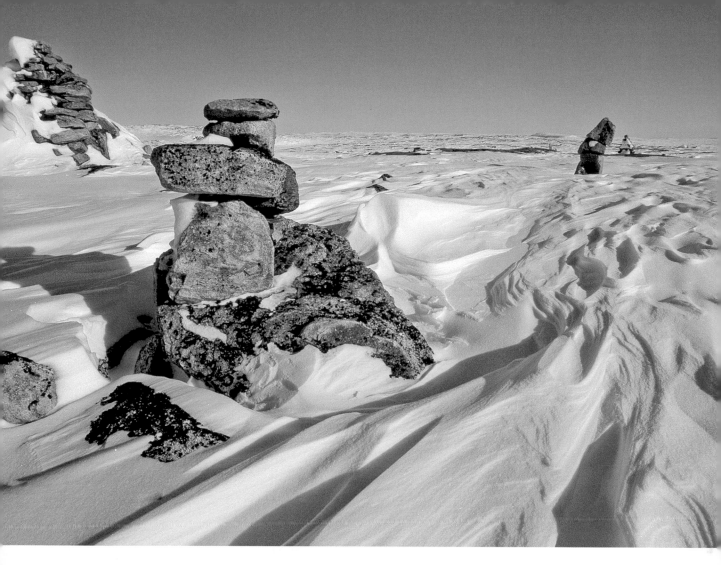

*left,* A "snow tongue" is a valuable sign when you are travelling great distances on overcast days across terrain with few landmarks. The "tongue" indicates the direction of the prevailing wind.

*above,* Wherever there are inuksuit, the traveller comes upon the footprints of people—and of blizzards.

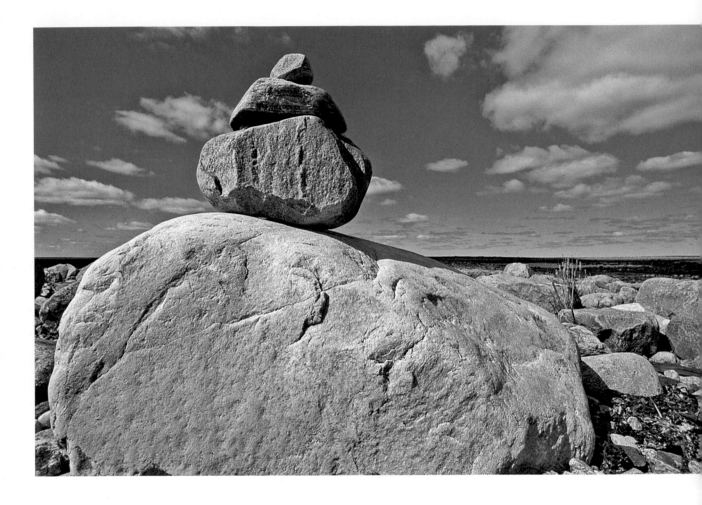

*left*, This simple inuksuk was placed near a good fishing spot on a river near Kangia, Sikusiilaq (Foxe Peninsula).

*below*, Situated near the passage at Itiliarjuk, this inuksuk indicates a cluster of small islands.

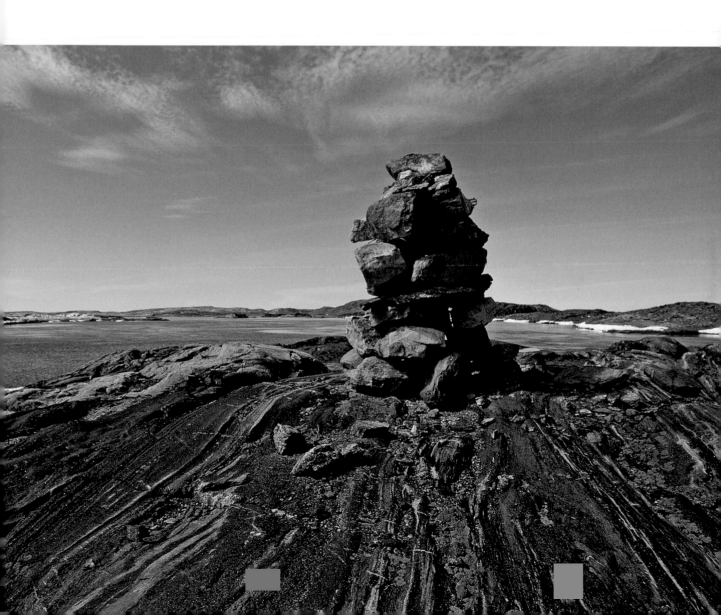

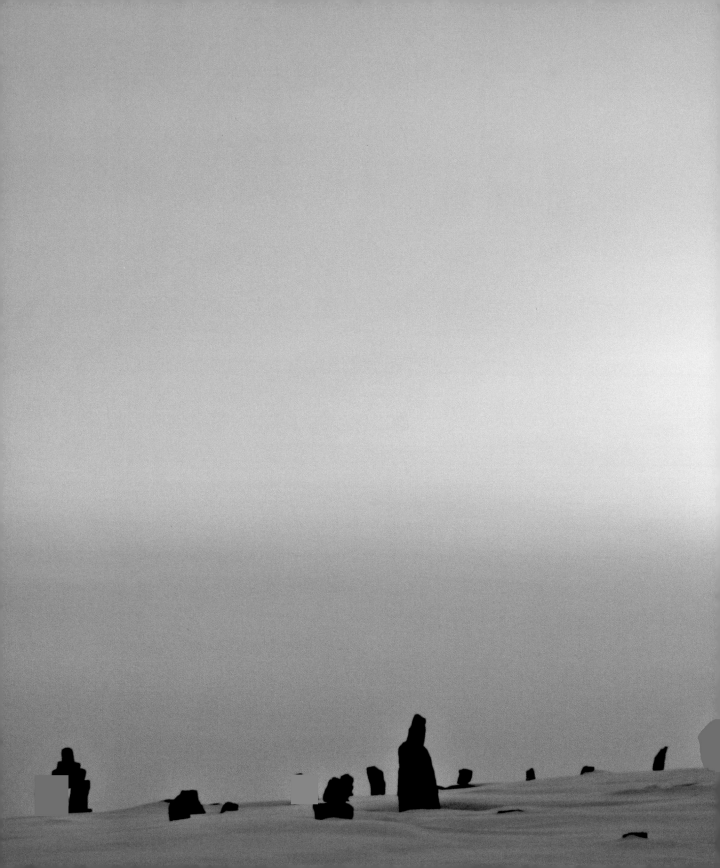

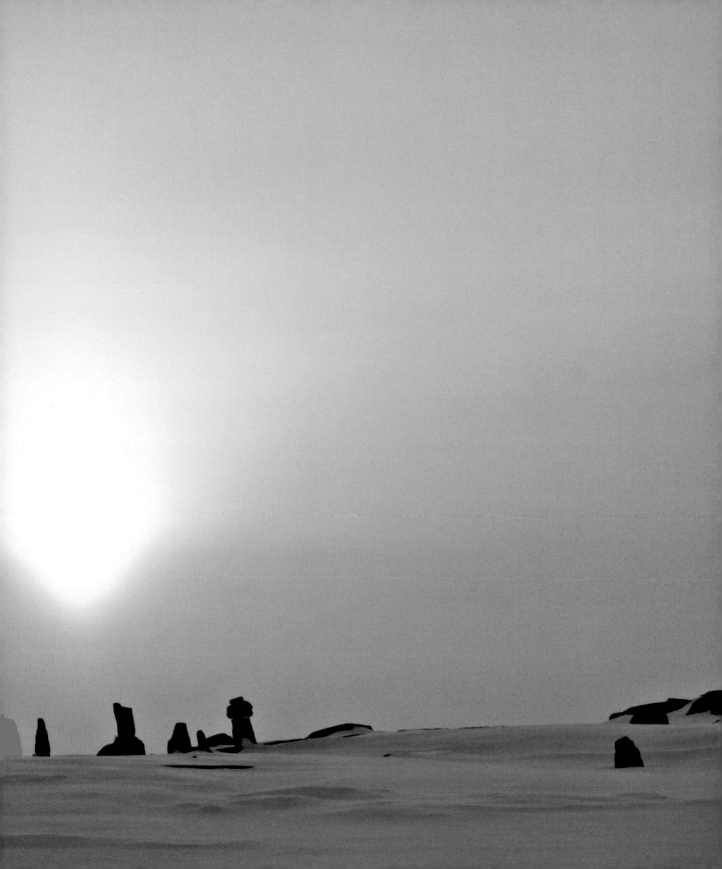

*previous pages,* A remarkable cluster of very old inuksuit on the west side of Kangisurituq (Andrew Gordon Bay).

*below,* An ancient inuksuk that stands at the edge of the caribou migration route in the central part of Sikusiilaq (Foxe Peninsula).

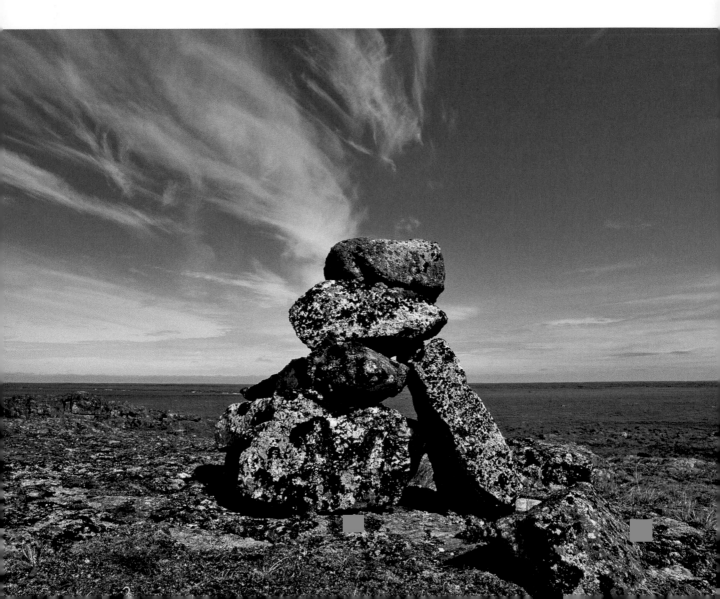

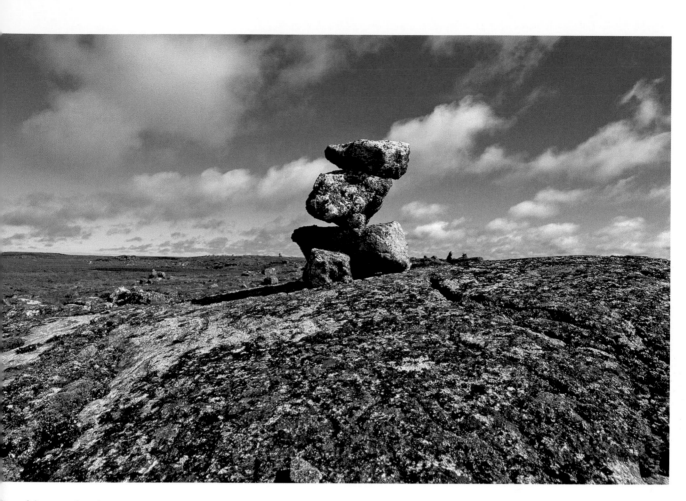

One of the more than three
hundred inuksuit at the tukilik
site in central Sikusiilaq (Foxe
Peninsula). Caribou were hunted
here with bows and arrows well
into the last century.

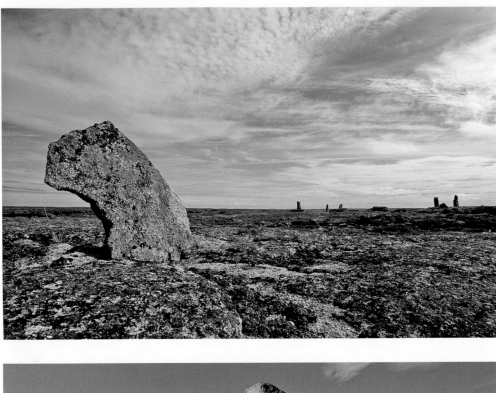

*left*, Unusually shaped stones, though rare and naturally occurring, were considered to be important inuksuit. This curved example stands at the far end of the tukilik site.

*below*, This oddly shaped stone marks the beginning of a pathway to an initiation site in the Piling Lake area, on central Baffin.

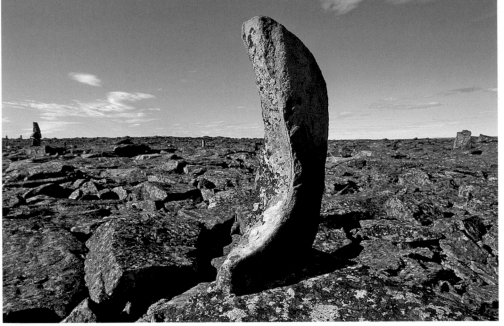

This inuksuk stands on a high ridge on the west side of Kangisurituq (Andrew Gordon Bay). It is a napataq, or standing stone, composed of white marble. This causes it to stand out like a beacon that can be seen from a great distance.

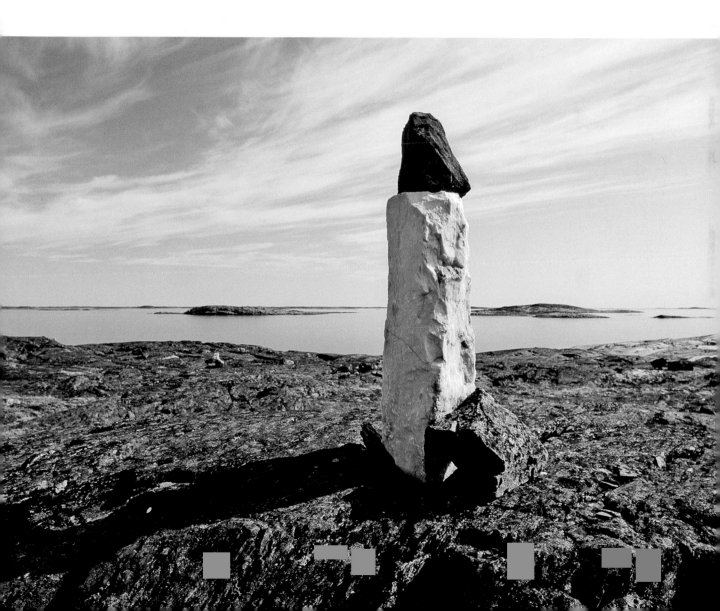

*right,* Perched on a rock in the Nares Strait between Canada and Greenland is a scruffy little innunguaq constructed of rocks that had to be flown in by helicopter. It is a symbol of Canadian sovereignty.

*far right,* These variously shaped inuksuit and sakkabluniit define an area on central Baffin Island where strict customs were once observed.

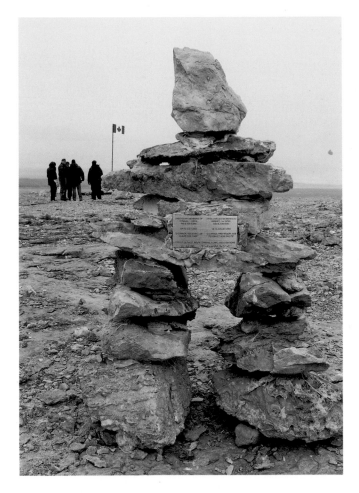

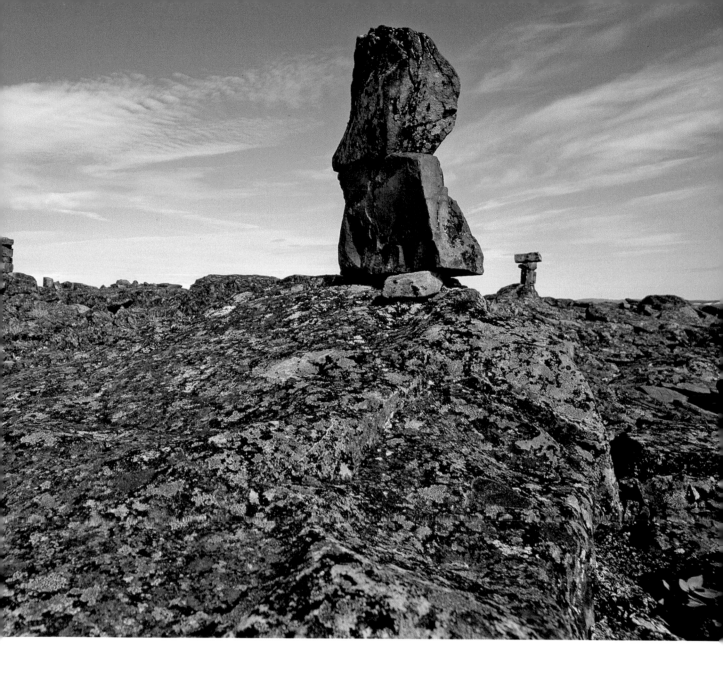

# taipkua atingit

## THEIR NAMES

While *inuksuk* is the most widely used spelling of the term, pronunciation varies from place to place. For example, in the western Arctic, the people say *inukhuk*; in the northern Keewatin, they say *inuhuk*; in the inland Keewatin, the Caribou Inuit use the term *inukuk*, while their neighbours in Qamanittuaq (Baker Lake) prefer *inu'ghuk*. In ancient times, the word was *inuksugaq*, and a few remaining elders in remote communities such as Kugaaruk (Pelly Bay) still use that term.

Inuksuk denotes one figure, *inuksuuk* refers to two figures and inuksuit is used for more than two. The term *inuksuks*, though widely used, is incorrect.

74

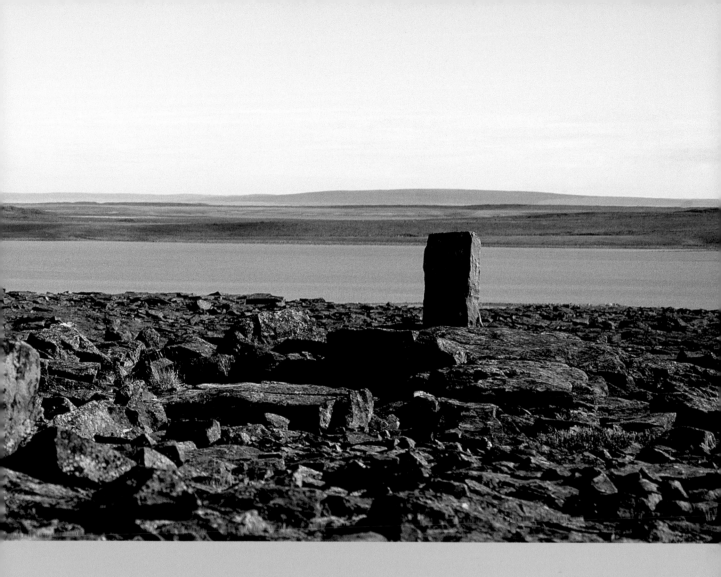

On southwest Baffin Island, I studied more than eighteen kinds of standing stone structures, each with a different name and a different function, but together making up a family of inuksuit. Here are just some of the types and functions of inuksuit in that one area:

| | |
|---|---|
| *aulaqqut* | an inuksuk for frightening caribou |
| *aluqarrik* | an inuksuk marking the best place to kill a caribou |
| *niptaniq* | a lookout marker for game |
| *napataq* | a standing stone or pinnacle |

These inuksuit near Longstaff Bluff on central Baffin link an ancient camp to a remarkable ceremonial site.

| | |
|---|---|
| *pirujaqarvik* | a meat cache marker |
| *hakamuktak* | a marker indicating that a meat cache is full |
| *nakkatain* | an inuksuk pointing to a good fishing place |
| *kaarrik* | a river-crossing marker |
| *itiniqarniraijuq* | an inuksuk pointing to the deep side of a river |
| *qaujiharialik* | an inuksuk pointing out a dangerous place in a river |
| *turaarut* | a pointer formed by placing one rock upon another |
| *turaaq* | a flat rock pointer |
| *tikkuuti* | a tilted rock pointer |
| *inuksualuk* | an image inuksuk, a navigational aid made from a stack of flat stones |
| *nakamuktuk* | a huge inuksuk, a navigational aid made from piled boulders |
| *tammariikuti* | a direction indicator |
| *niungvaliruluk* | a directional inuksuk composed of vertical and horizontal stones forming a "window" for sighting or aligning |

A nalunaikkutaq, a common sort of inuksuk whose name literally means "deconfuser." It acts as a mnemonic, reminding travellers of a certain action or direction to take when they reach it.

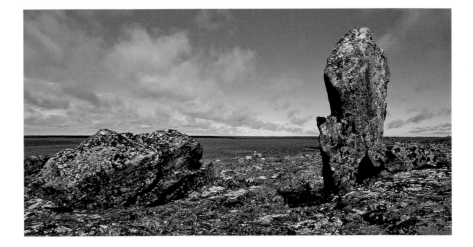

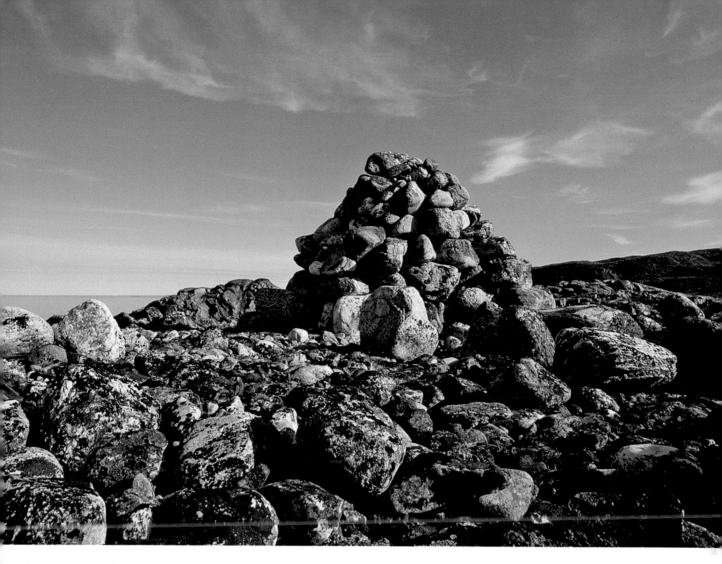

ome inuksuit resemble cairns,
ecause the only stones available
were boulders.

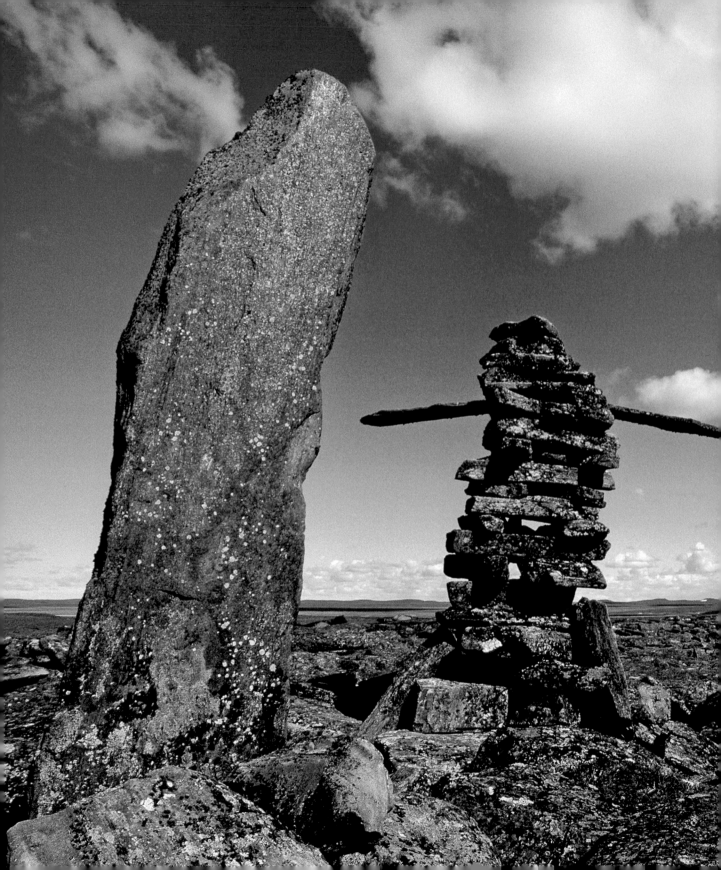

An unusual pair of inuksuit in the Piling Lake area, on central Baffin. The figure in the foreground is a nalunaikkutaq; the one in the background appears to be an innunguaq but is not. It is a unique structure. The long, narrow stones are arranged like the bars of a crib, creating openings. What appear to be arms are actually pointers which can be moved in various directions. This is an example of a *semalith*, a stone messenger.

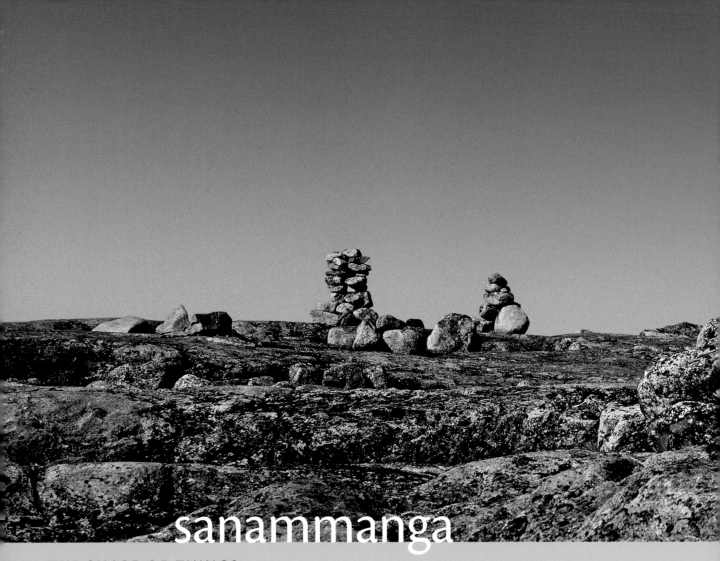

# sanammanga

## THE SHAPE OF THINGS

Made as they are of loose stone, inuksuit can be found in countless sizes, shapes and forms. They can be large, small, slender or squat. The tallest stand higher than two men, one standing upon the shoulders of the other, while the smallest are no higher than the thickness of a slab of stone (these are *turaaqtiit*, pointers showing the best, though not necessarily the shortest, route home). The most common height of an inuksuk is around 120 centimetres, the highest an average person can lift a fair-sized stone while keeping his arms close to his body. Inuksuit taller than people are rare. The elders call such a structure an *inuksullarik*, which means "a very important inuksuk." Most were built by several men, often working from temporary platforms of stone found nearby.

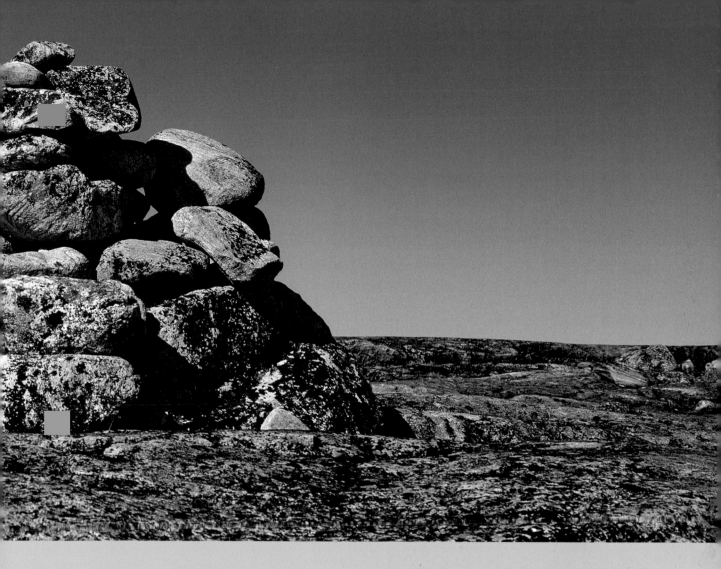

Three factors determine the shape an inuksuk takes. Most important is the shape of the raw rock, which largely determines the size and general appearance of the finished structure. Rounded boulders offer the fewest possibilities for shaping an inuksuk, because about the only thing you can do with them is stack them into a pyramid. Such inuksuit tend to be massive, because they need a broad base to reach a reasonable height. Known as *inuksummariit* or an *inuksukjuait*, they often serve as important direction indicators.

Large slabs of stone can be arranged in more interesting ways. Two slabs stood on end form the supports for a lintel, which can then become part of a quite elaborate

This huge inuksuk made of boulders marked the way to a major inland travel route on southwest Baffin.

structure. One of the more distinctive shapes is the *niungvaliruluk,* a "window" which acts as a sightline framing some distant place of great importance.

Irregular, angular and broken rock offers the widest possible variety of form. Carefully balancing one rock upon another takes great care and patience. I've often watched an elder study a jumble of broken rock, visualizing how one piece would fit with another, without so much as touching a single stone. When he could see the finished inuksuk in his mind's eye, and only then, he would tell his helper to move the first selected stone into place, and construction would begin. The form that emerges is determined as much by the shape of the stones as by how they are finally arranged by the builder.

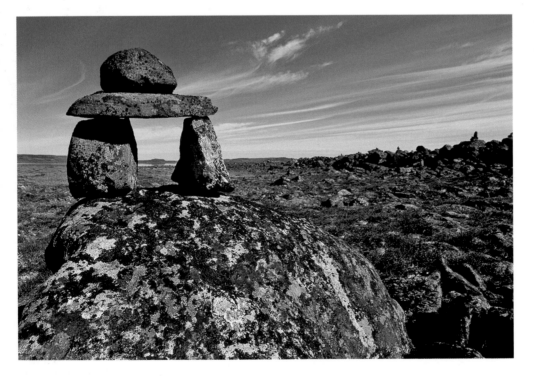

*left,* This central Baffin niungvaliruluk framed the place where caribou crossed the river every year.

*right,* This niungvaliruluk on the west coast of Sikusiilaq (Foxe Peninsula) is part of a line of sight extending from Inuksugalait to Nurrata along some ninety kilometres of this often treacherou coast.

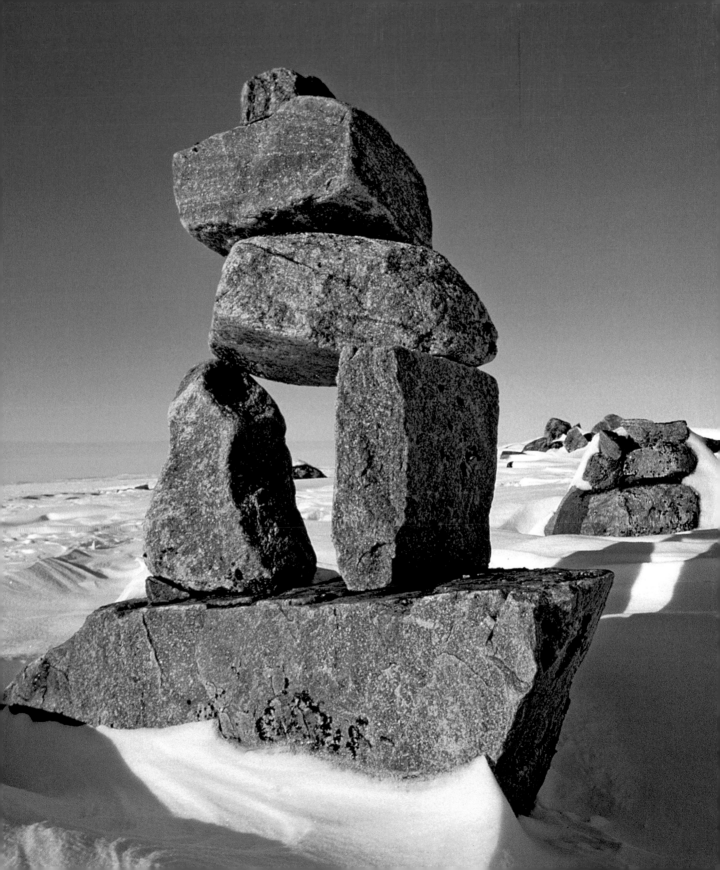

One distinctive kind of inuksuit was used to frighten caribou towards waiting hunters. In south Baffin these inuksuit were known as *inuksuit tuktunnutiit*. They were often only hip high. A large clump of plant material was placed on top and held in place with a stone. The long tendrils of the plant would blow about in the wind, creating the appearance of an eerie creature looming upon the hilltop. More elaborate variations were found in Nunavik, in Arctic Quebec, where they were referred to as *aulaqquit*, which literally means "scarecrows" or "bogeymen." Some had the dried, outstretched wings of seagulls dangling on sinew lines from their tops. These would flutter in the wind, creating threatening shapes that spooked the caribou.

Even more intricate were hunting inuksuit which had the capability to make sounds—to speak, as it were. These often had bones such as caribou ribs or scapulas dangling from their tops. The slightest breeze would cause them to click and clack quite loudly, making an eerie chorus in an otherwise silent landscape.

Even a casual observer will recognize five general groups among the countless variations in inuksuk shape. The first contains the innunguait, described above, with their distinctive human-like forms. The second group is made up of the *tikkuutiit*, or pointers. These, in turn, come in three variations. The most common variation is little more than a slender rock placed on a base of stones pointing in a specific direction; the second is a triangle-shaped rock, often found lying flat upon the ground with its dominant side pointing towards the direction to be taken; and the third is the straight line of rocks laid upon the ground, with the largest rock at one end and the smallest at the other, denoting the direction to be taken.

The third group of easily recognized inuksuit consists of the *inuksummarik* or *inuksukjuaq*, huge structures that can be seen from a great distance. These large inuksuit act as major coordination points—places to gather before travelling inland for the summer or before heading home at the end of a long, seasonal journey. The fourth kind is the niungvaliruluk: distinctive, window-shaped inuksuit which may form a sightline or frame the view of an important place or object.

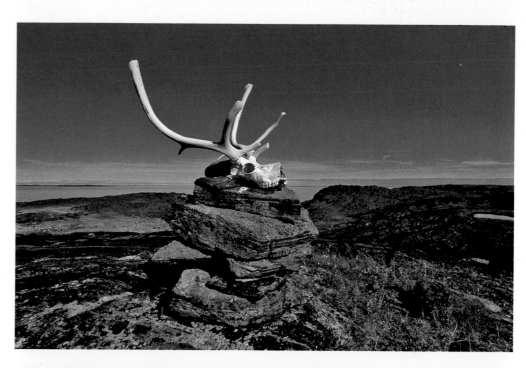

*right,* The elders of south Baffin called this kind of inuksuk a pirujaqarvik. The caribou skull told travellers that a meat cache was nearby—and helped the wind to blow the snow off in winter.

*below,* This huge, single slab of granite, some four metres long, was probably intended to be raised upright. It is located at Kungia, one of the most complex ancient sites in southwest Baffin.

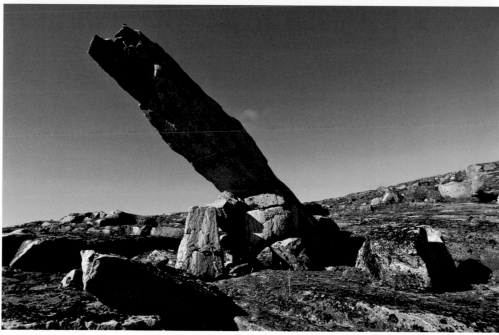

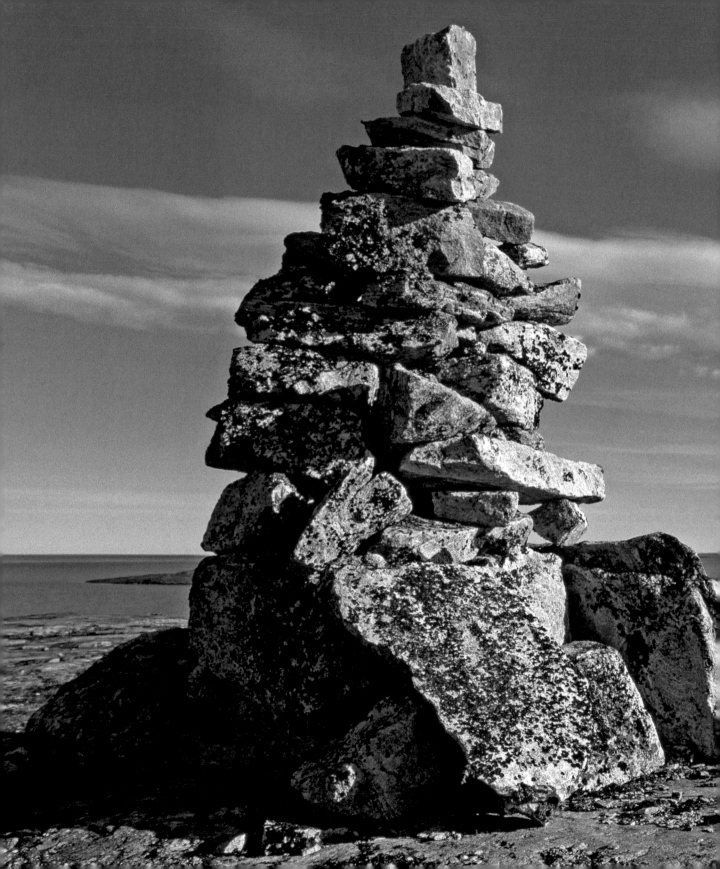

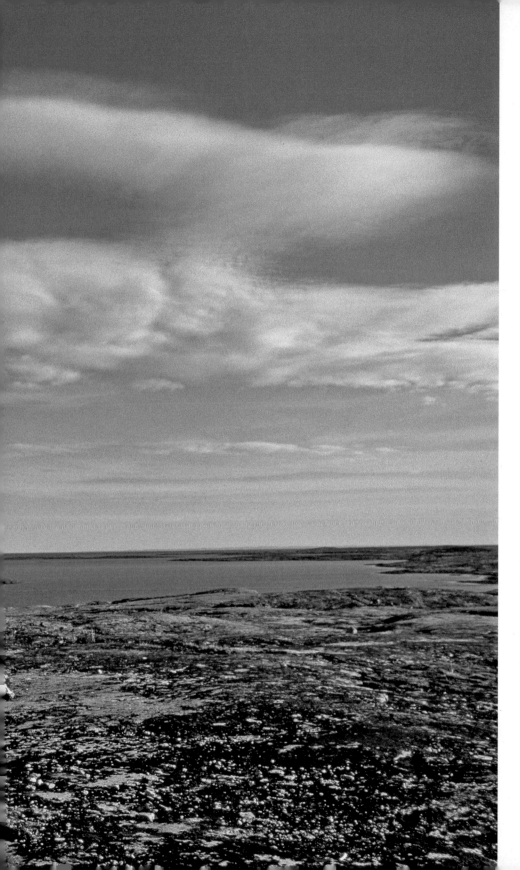

This large inuksuk acted as a beacon on the way to Kangisurituq (Andrew Gordon Bay). In the nineteenth century, whalers sometimes mistook such cairn-like inuksuit for caches and dismantled them in search of their supposed contents.

Finally, there are inuksuit which have a secondary function as message centres. These can be recognized by an arrangement of stones at their base, left there by a hunter as a message for a follower. The arrangement might signify a change of direction from an intended course, or serve as a caution or a sign for the follower to go to an alternative location or the camp of a relative. Hunting partners or members of a family knew how to decrypt such messages.

Now comes the important question of how to read the meaning of an inuksuk. For example, how do we know if an inuksuk marks a place where the ice is dangerous at a certain time or a spot where food is cached for winter? How would we know if what we thought was an inuksuk was in fact some other object, such as a tunillarvik—a stone believed to provide healing and protection—or a dreaded angaku'habvik, where shamans were initiated?

The simple answer is that each inuksuk's unique shape is its primary message. For the Inuit, the faculty of visualization—being able to record in the mind every detail of the landscape and the objects upon it—used to be essential to survival. Part of this skill was the ability to memorize the location of places in relation to one another, and in stretches of featureless landscape, an inuksuk was a great helper. Skilled hunters memorized the shapes of all the inuksuit known to the elders, as well as their locations and the reasons they had been put there. Without these three essential pieces of information, the messages the inuksuit contained were incomplete.

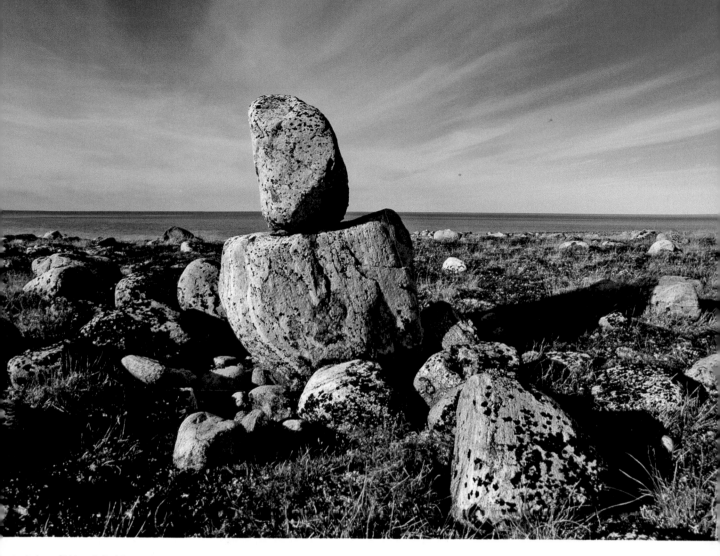

...t Arviatjuaq (Eskimo Point) is a
...mple inuksuk that looks like a cup
...to which a stone is about to fall.
...he message it tells is, "Remember
...his place, for here a powerful angakok
..."shaman") received his power."

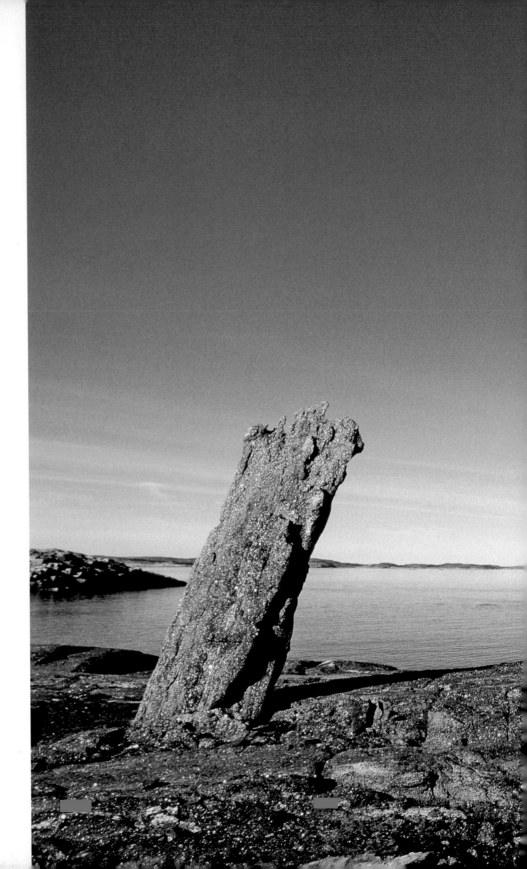

Three of a larger group of stone figures, including inuksuit and a niungvaliruluk, on a small island in Kangisurituq (Andrew Gordon Bay).

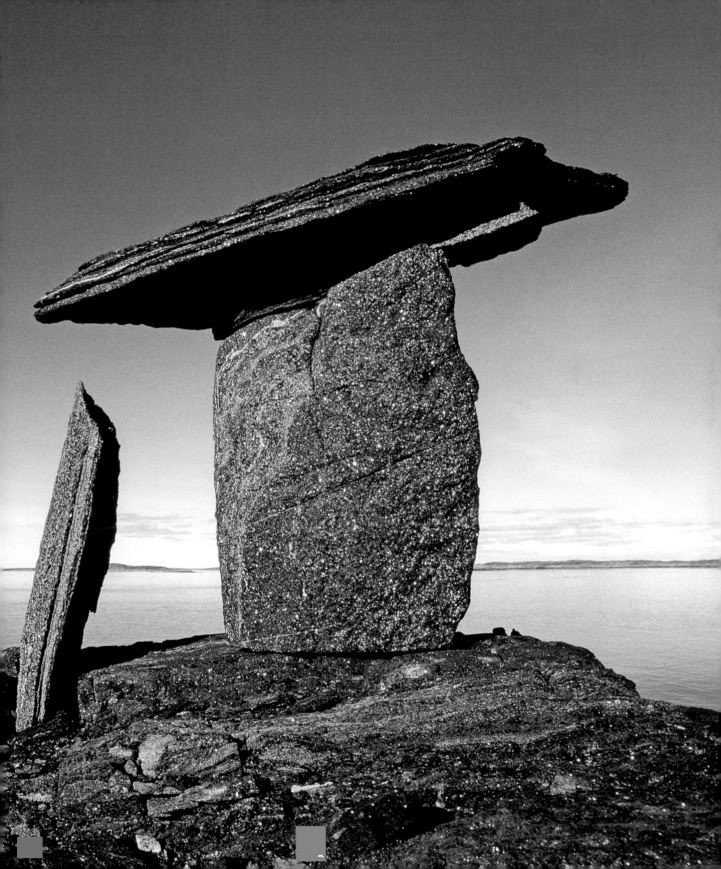

Stark inuksuit perch, pointing
straight up, on a ridge on a
small island off southwest Baffin,
surrounded by treacherous
currents at full tide.

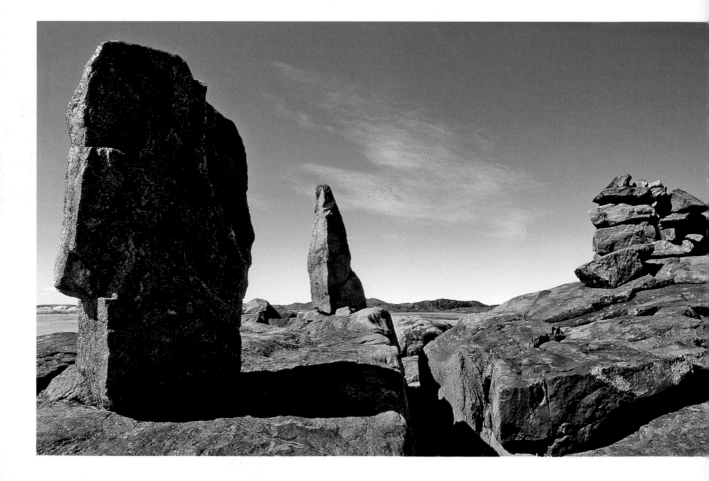

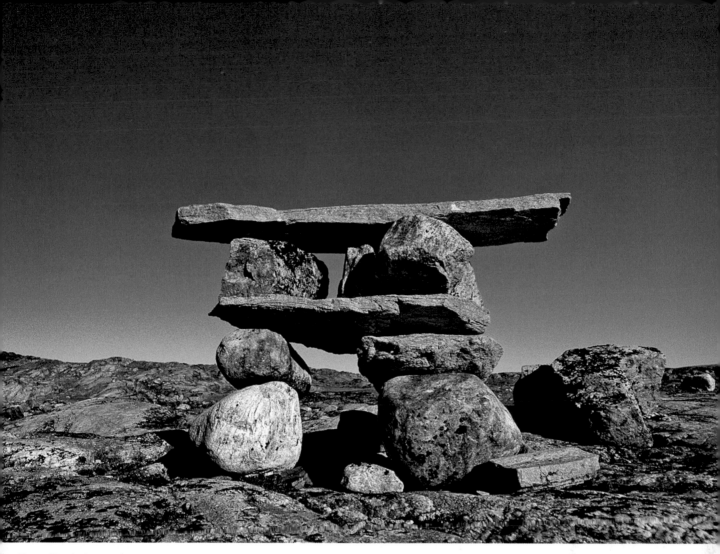

This "layered" inuksuk, one of
several found across central and
southern Baffin near old camp
sites, may indicate a favoured
location.

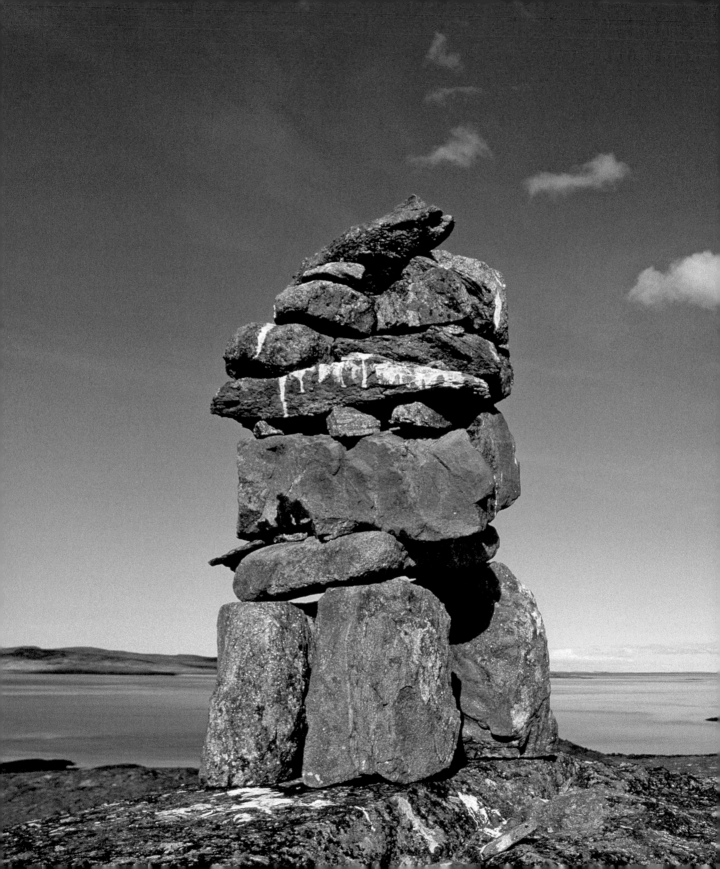

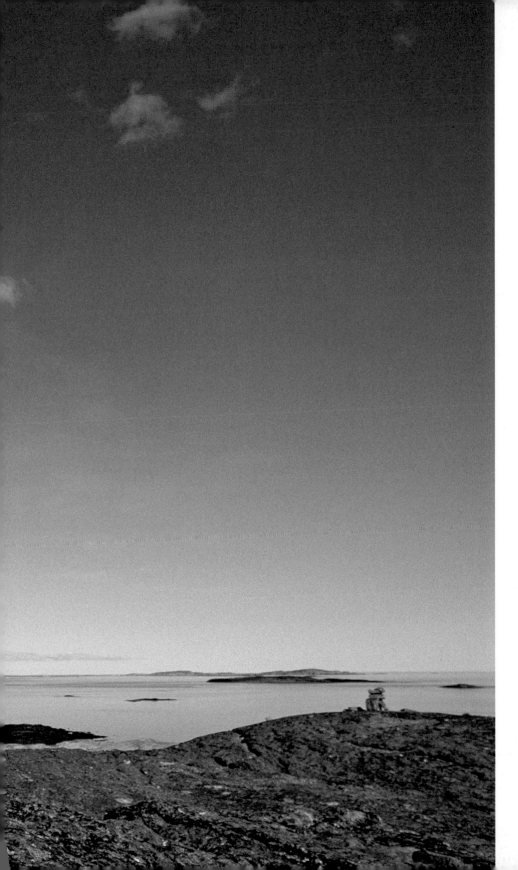

A huge inuksuk which is at least two to three hundred years old might be called an inuksugaq or inuksullarik. Such inuksuit are often shrouded in lichens and provide a perch for countless birds. At their base is a micro-ecosystem nourished by bird droppings and the seeds within them; with protection from the wind and sufficient moisture, Arctic plants flourish, attracting butterflies, bumblebees and other insects.

# tukisianiq nunamik

## THE LANGUAGE OF THE LAND

The location of an inuksuk is as important as the inuksuk itself. Most of the inuksuit were built in high places, where they could be seen from miles away across the vast and generally flat Arctic landscape. Inuksuit which act as either location beacons or coordinators to help you get your bearings are almost always found on the crests of hills, where their silhouettes can be seen from a great distance. Inuksuit used to mark a food cache likely to be visited in winter were often topped with the antlers of a caribou, conspicuous elements that could be seen from afar even when drifting snow obscured the cache below. A clever and very important type of inuksuk was made of ice and snow and strategically placed near the place

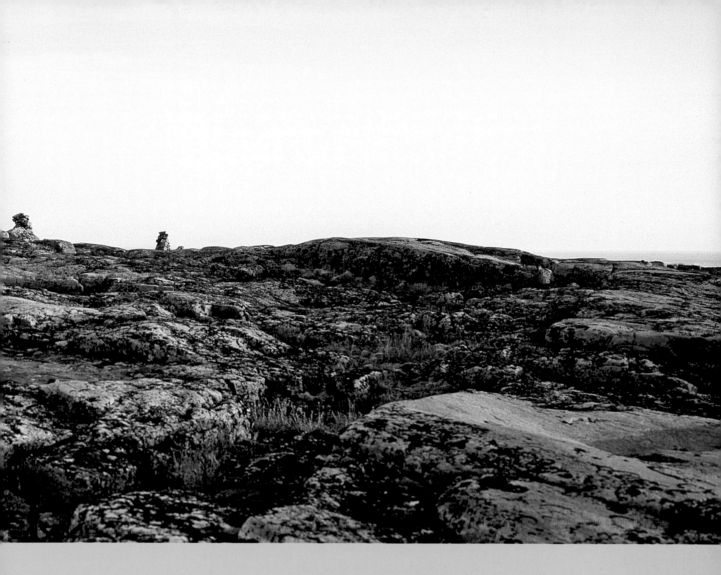

where the sea ice became dangerously thin in spring, thus acting as a warning to travellers. Eventually this warning sign would disappear, to be rebuilt the following year.

Inuksuit can still be seen in various parts of the Arctic. One of the most "populated" places is southwest Baffin Island, particularly in the Kinngait (Cape Dorset) and Kimmirut (Lake Harbour) areas. In traditional times when hunting was still done with bow and arrow, inuksuit tuktunnutiit were placed in carefully arranged patterns, usually "V" shapes that could extend for a great distance. One such hunting site I visited was one and a half kilometres long and eight

A hauntingly beautiful site at Inuksugalait in summer. For centuries, hunters have created inuksuit at this special place, leaving messages on the landscape for future generations.

hundred metres across at its widest point, funnelling down to a narrow gap where the hunters lay waiting in their shooting pits.

Other inuksuit were arranged to take advantage of the topography in places where caribou could be concentrated, such as by creating a "fence" to drive the animals into a dead end surrounded by cliffs. Other inuksuit fences forced migrating caribou to cross a river at certain points or pushed them into a lake at a place where they were easy to kill. Inuksuit arranged in these fence-like patterns were four to five metres apart; women and children would spring up in the gaps at the critical moment, shouting and waving their arms to terrify the caribou towards the desired direction.

In 2002, I came upon a site in central Baffin Island where inuksuit had been put to work in a most ingenious way. The area contained a number of freshwater ponds where Canada geese fed and nested. I counted over a hundred inuksuit near the ponds and observed that they generally fell into groups of two sizes: one group was approximately one and a half metres high—the height of a standing hunter—and the other was about eighty-eight centimetres, the height of a seated figure. This was not a coincidence.

The "standing figures" were arranged in a long line up on a ridge facing the lake, while the "seated figures" were close to the various ponds where the geese nest and raise their young. Inuit hunters have told me that geese are very sensitive to any changes in the landscape. The men who hunted here long ago knew this, so they built replicas of themselves both standing about and seated near the ponds. Over time, the geese came to accept these intruders as part of the landscape. This brilliant deception worked: the geese returned and did not notice that some of the inuksuk-like figures were moving towards them in the twilight. Season after season the hunters captured and killed many birds.

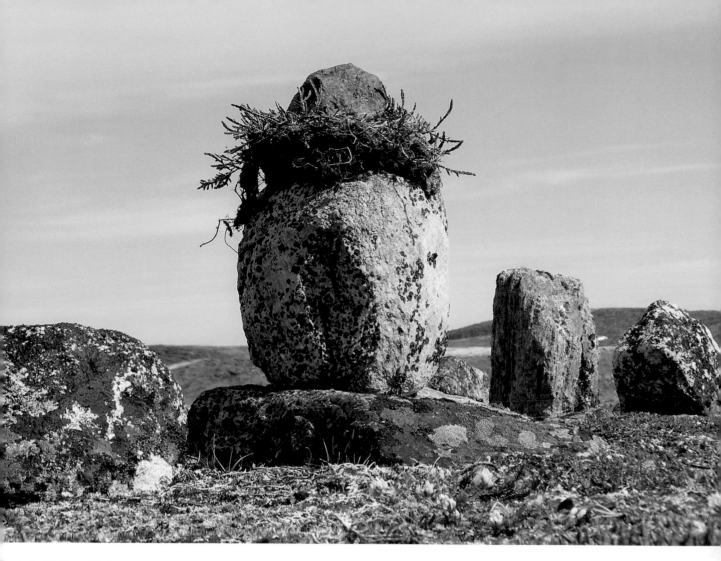

The *inuksuit tuktunnutiit* of
Southwest Baffin were "hunter's
helpers." The wind would set the
tendrils of the Arctic heather
placed upon them into motion,
frightening the caribou towards
the waiting hunters.

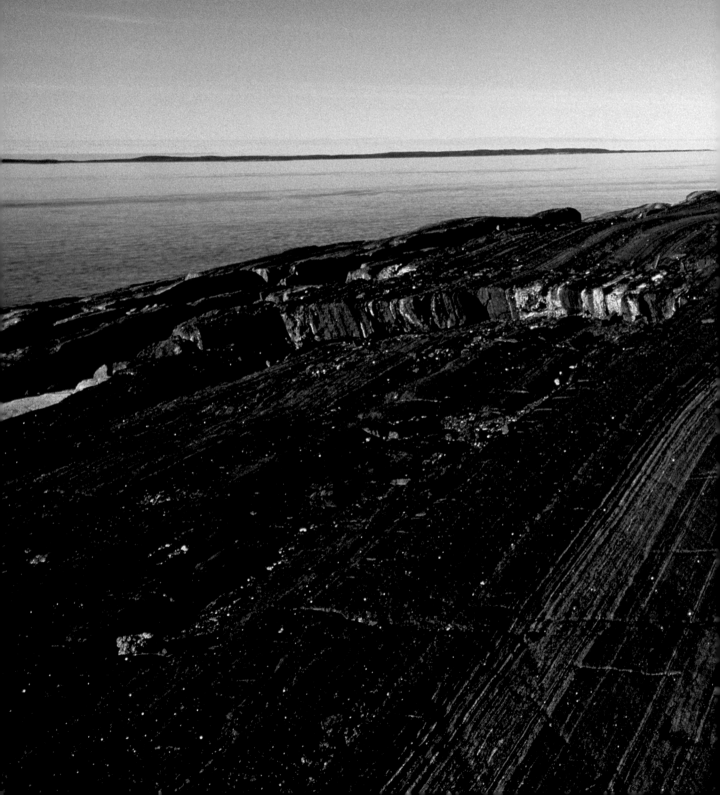

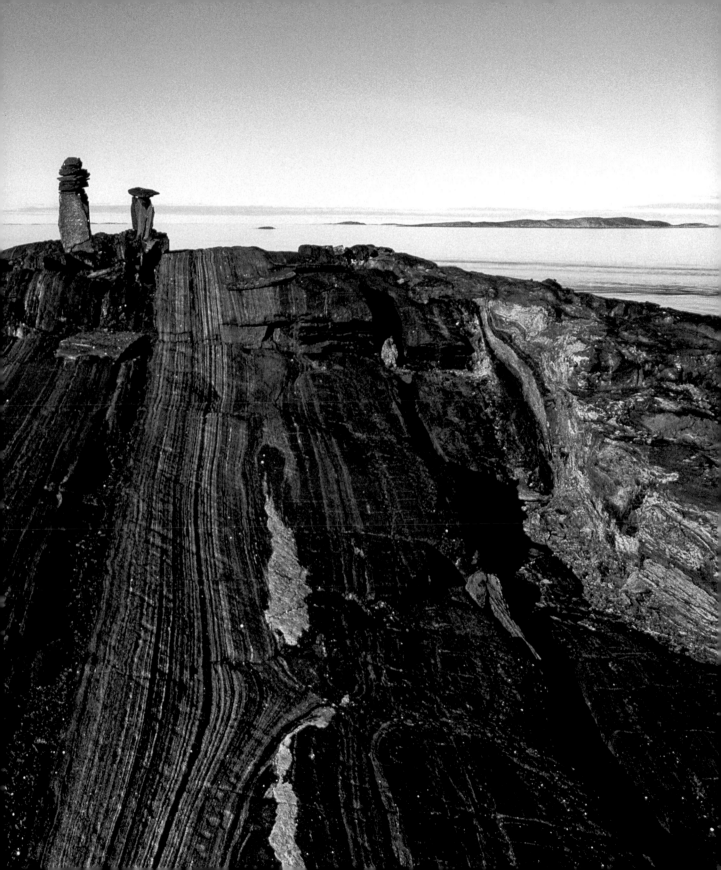

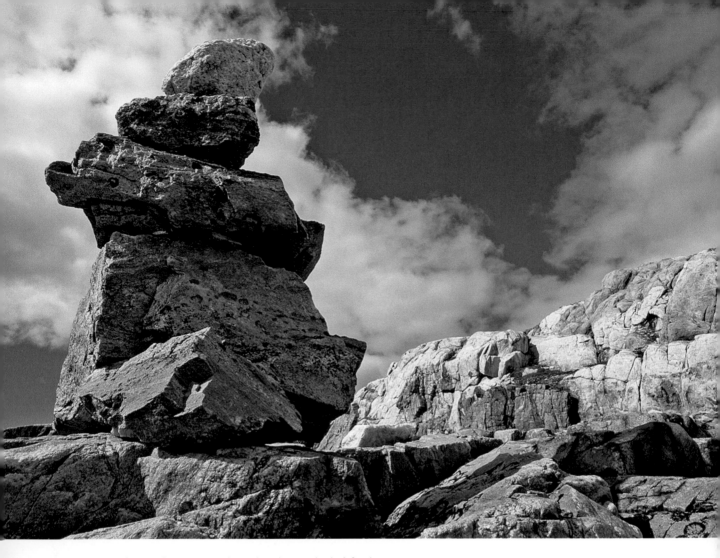

*previous pages*, Inuksuit at the north end of Alariaq Island, off southwest Baffin Island.

*above*, Though not a clearly defined innunguaq, this inuksuk near Kungia, when seen from the sea, resembles a human figure.

A fine example of a niungvaliruluk "window," framing Tellik Inlet. It bears a striking resemblance to the structure built by Peter Irniq at Juno Beach (see page 57).

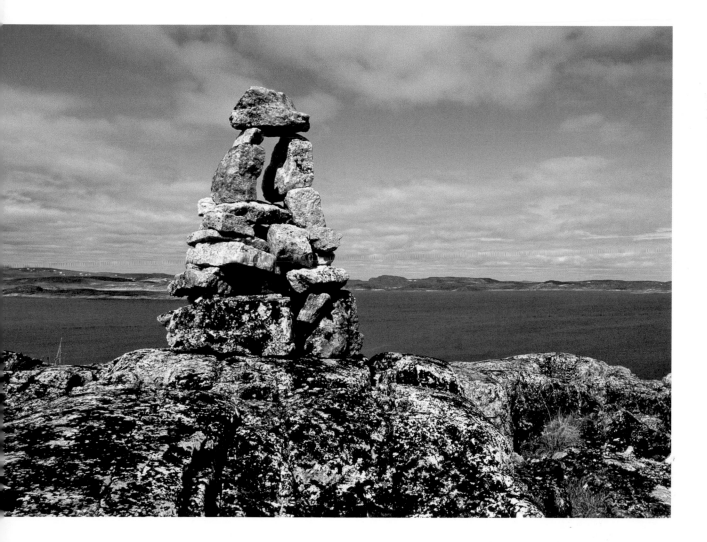

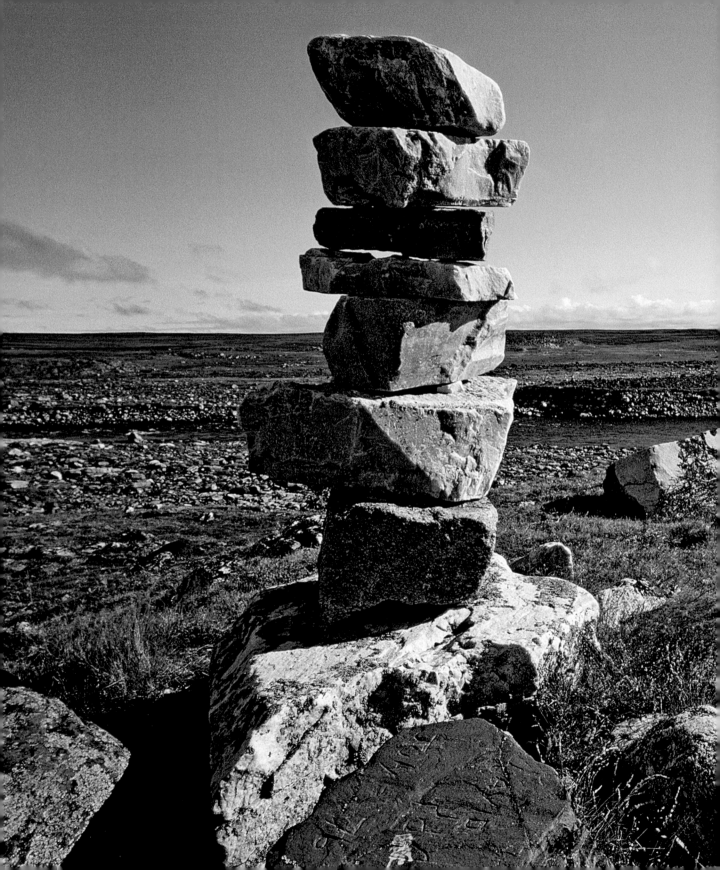

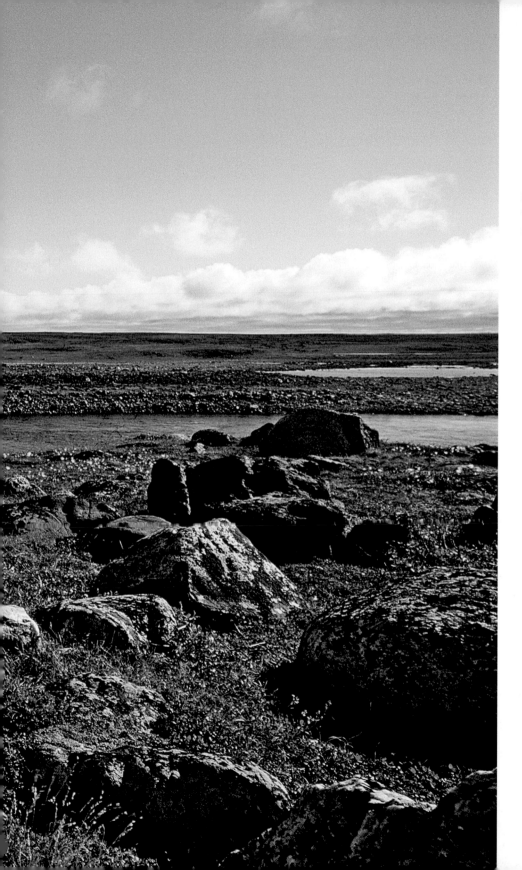

Near the ancient fishing site at Sapugaqjuit stands this inuksuk, which marks the place where people camped in summer.

This *varði* (plural *varðar*) is one of several on the Faroe Islands, an enchanting archipelago between the Norwegian Sea and the North Atlantic. They are similar to many inuksuit in their form and function.

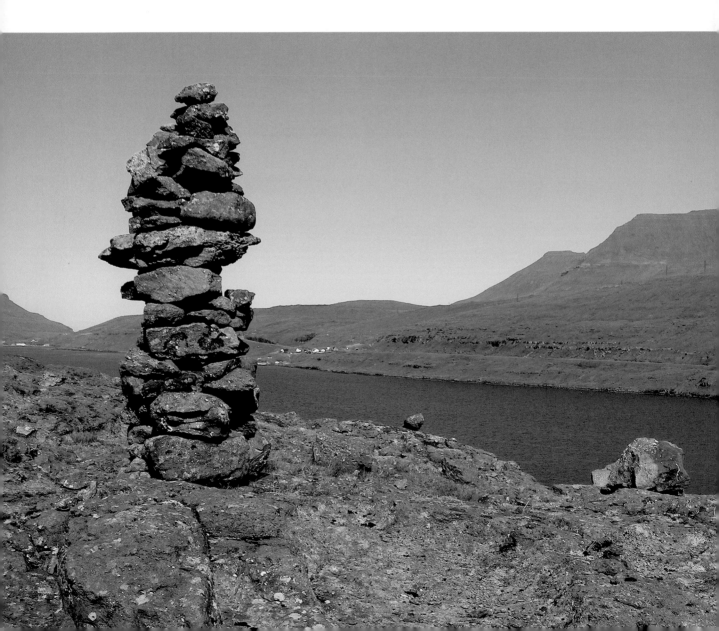

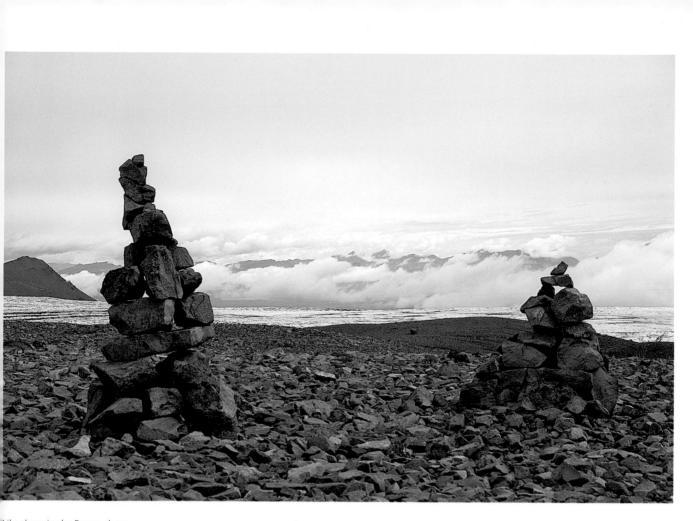

Like those in the Faroes, these
varðar in Iceland mark ancient
travel routes.

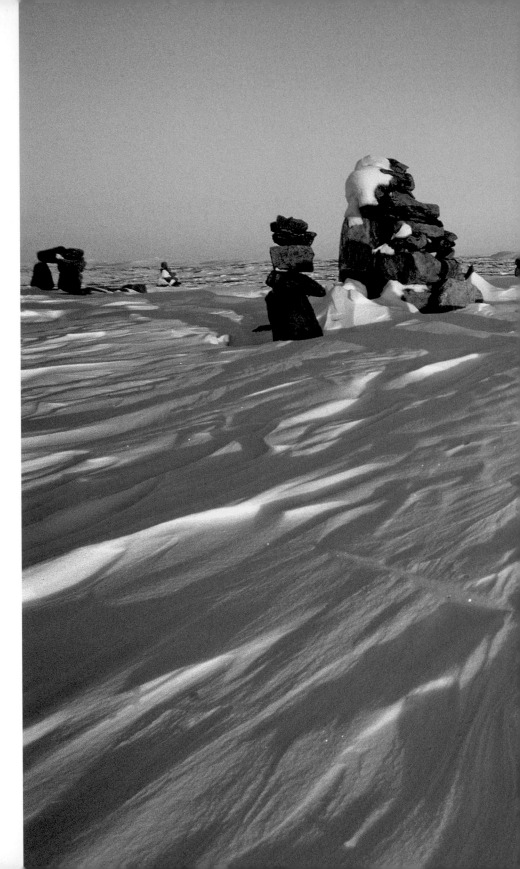

Hard, compacted snow at the base
of inuksuit indicates the direction
of winter blizzards; in this case the
prevailing storms sweep down from
the northwest.

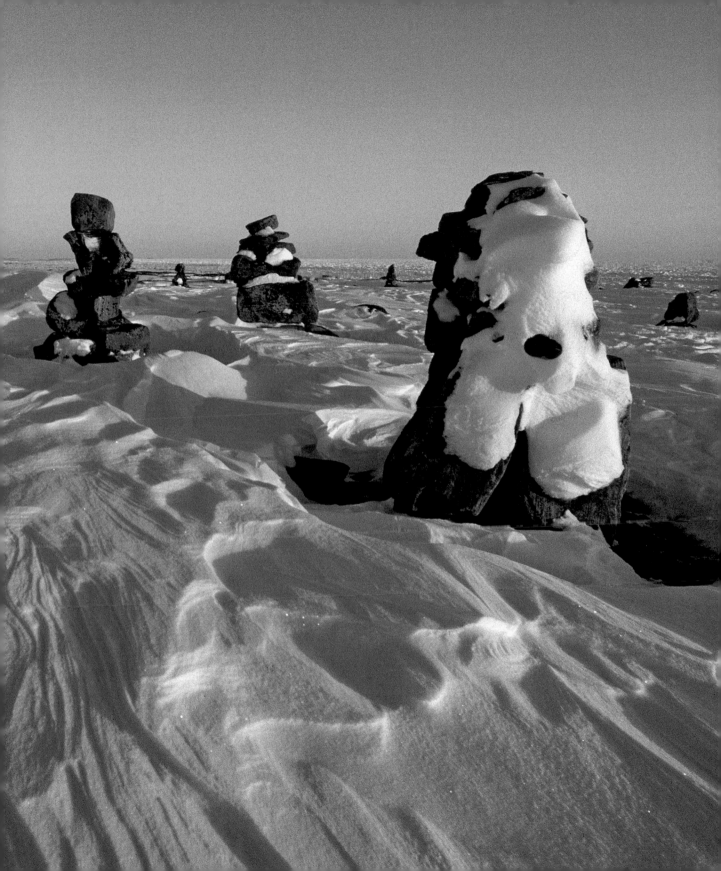

An inuksuk standing high above the
settlement of Qaqortoq, Greenland.

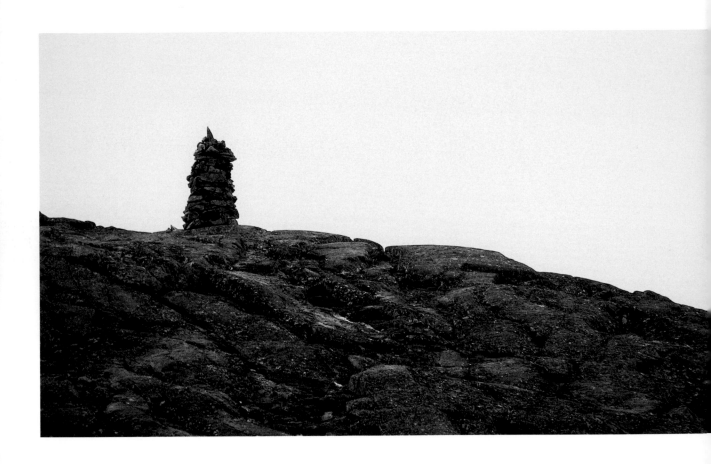

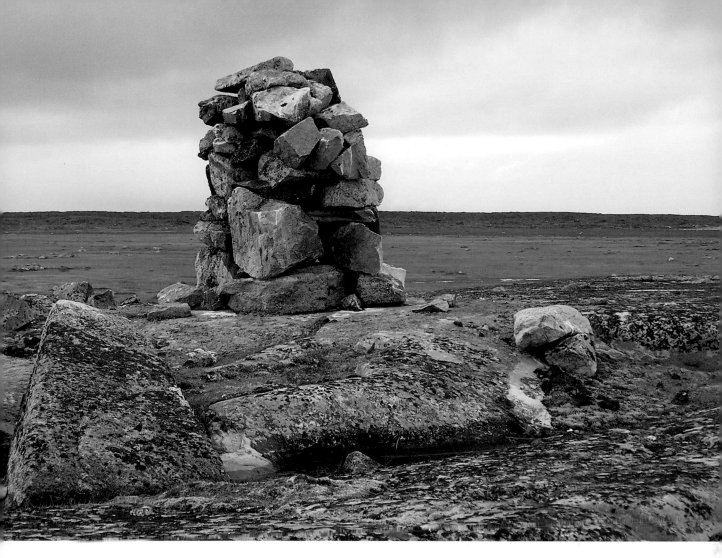

*above,* The sturdy inuksuk marking the boundary between Sikusiilaq (Foxe Peninsula) and the Great Plain of the Koukdjuak to the north. This is one of the most important coordination points in the entire area.

*following pages,* The powerful landscape of the Kinngait (Cape Dorset) area, which has been home to Inuit since their predecessors arrived some three thousand years ago, during the *inuit sivulliit tamaanigiagnaliqtillugit,* "the time of the earliest humans."

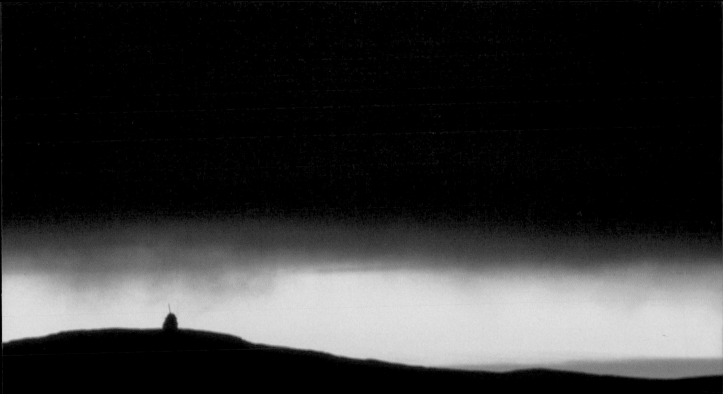

# ananauvok

IT IS BEAUTY

Southerners often describe the Arctic as a remote, cold, harsh and unforgiving environment. The Inuit elders I know are puzzled by our use of such hard words to describe Nunatsiaq, the beautiful land. Their language abounds in expressions of beauty, which they use to describe the weather, the land, thoughts, even the sound of certain words. The *uqausiit tusaruminaqtut* ("archaic words") are beautiful to hear, though some of them are so ancient that their meanings are no longer remembered. Even we southerners can find beauty in some of the old beliefs and legends.

One of the first spirits to descend upon the land when it had just emerged from the sea was Qujjarnaq. She was a great bird who lived at the very edge of the world.

114

When the shamans called upon her to heal the sick or to send forth the animals to feed the hungry, Qujjarnaq radiated an aura of bright light and great beauty.

When one is travelling along the southwest coast of Baffin Island, it is not unusual to come upon both ancient and recent remains of summertime camps. They may consist of little more than a few tent rings, pieces of broken equipment, and perhaps a forgotten child's toy or an abandoned kerosene lamp. These camps are located in places where countless generations of families have lived during *aujak*, that brief period that southerners call "summer." They are embedded in the memories of everyone who lived along the coast.

The delicate dwarf fireweed (*Epilobium latifolium*), *paunnat* to the Inuit— spreads its vibrant colour throughout the Arctic, often growing where the earth has been scarred, bringing beauty to the landscape. The flowers and young leaves can be eaten raw or brewed as a delicious tea to soothe the spirit and calm an upset stomach.

These are places where children were born, where a boy and girl fell in love or an elder spent his or her last summer on Earth. Nearby, one may come upon a beautiful valley or a little patch of delicate wildflowers. I remember well being told by a lovely young woman that these were the places where generations of lovers had spilled their passions upon the land, bringing forth its beauty. The sheer joy of being on the land at a summer camp often led the Inuit to place a little *inuksuapik*, an especially beautiful inuksuk, nearby as a token of thanks or a sign of reverence.

· · ·

Several friends have asked me how to go about building an inuksuk in their garden. Before you begin, ask yourself: what do you want it to be? Is it to be a garden ornament, or is it to have meaning? So much depends on why, rather than how, you create it. In our garden stands an inuksuapik that literally came out of the ground. While we were excavating for an extension to the foundation of our house, we uncovered three huge granite boulders. Rather than dumping them, we carefully arranged them into a large inuksuk. In the beginning it was little more than an impressive garden ornament. However, something happened that transformed the inuksuk into an inuksuapik.

The process began when the snow started to fall during the inuksuk's first winter. One morning we noticed that cardinals had come out of the cedar bush and perched upon the figure. In a matter of days, they were joined by chickadees, then finches and juncos. We began leaving seed upon the inuksuk, which in turn attracted red, black and grey squirrels. Then, one blustery winter morning, a small deer appeared, foraging for the few seeds the birds had left. She was unusually thin, scruffy and alone. And so we began to feed the little starving creature, as well.

By the time spring arrived, we had a beautiful menagerie of wildlife that appeared every morning at the inuksuk in our snow-covered garden. It was no longer just an ornament—it had become an inuksuapik. My wife began to refer to it as Miri, in memory of her mother, who until her final time on Earth had been greeted each morning by the songs of the wild birds she fed and loved so much.

Whether they stand on a windswept hill in the High Arctic or mark a pilgrim's lonely trail in the Himalayas, whether they are a solemn tribute on the edge of a battlefield or stand in a rose garden, inuksuit evoke a sense of belonging. They define that single point on the horizon of the imagination and so give meaning to *kajjaarnaq*, an ancient expression in Inuktitut which means, "There is great beauty in fond memories."

The inuksuk we named Miri. Born from the ground, it became a winter haven for birds, deer and other wildlife and an object of fond memories.

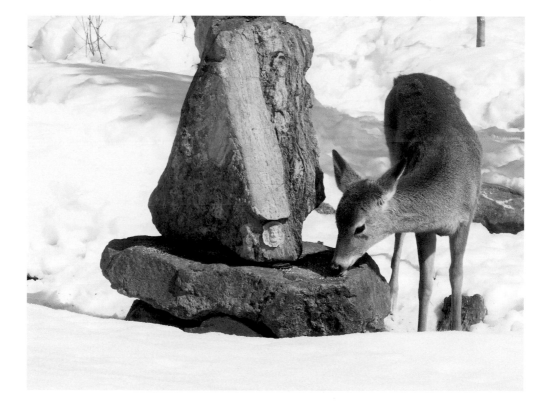

To my friends in the Arctic, France, Spain, Germany and Japan I offer this overview of inuksuit in your respective languages, with the hope that some day you may enjoy the full text with your children.

ᐅᏢᐅᏌᏟᏴᏗᎤ᎐Ꮻ ᖅᏙᎴᎧᏟᏗᏯᏟ ᓂᏞᖅᏴᎷᏸᏗᏟᏢᏫᏬᎤᏟ

ᏬᏌᏚᎧᏟ ᖃᏟᎯᏰᏌᏳᏋᏟᏟᎤᏞᏱ ᏟᏈᏟᏟ ᎠᏬᏱᏟᎤᏸ ᏟᏝᏸᏟᏟ ᏟᏸᏌᏟᏬᏸ ᏢᏝᎤᏢᏌᏴᏙᏌ ᎤᏢᎤᏌᏟᏋᏢ ᎤᏬᏸᏱᏝᏟᏬᎤᏟ ᏝᏬᏴᏟᏸᎧᏟᏴᏝᎯᏝᎧ ᎠᎤᏸᎤᏟ ᏟᏟᏳᏓᎤᏟᏬᏟᏬᏸᏱᏟ; ᏸᏟᏟᏟᎥᏟ ᏢᏝᎤᏢᏌᏟᏟᎧᏬᏌᏢᏟ ᏟᏝᏬ ᏟᏟᏴᏌᏟᏌᏢᏟ, ᎠᎤᏸᏁᏌᏟ ᏟᖅᏢᏳᏝᏬᏴᎥᏬᏟ ᎠᎤᏸᏌᏴᏟᏌᏌ.

ḈᏟᏟᏟ ᏢᏌᏌᏟᏟ ᏟᏟᎥᏟᎧᏟᏌᏌᏢᏟ ᏌᏌᏴᏟᏟᏌ ᏬᏝᏢᏣ ᏝᏌᏨᏳᏟᏯᏽᎤᏟᏟᏳᎯᏸᏋᏲ ᏝᎤᏬᏟ ᏟᏟ᏾ᏟᏟᏟ ᏟᏳᏌᏝ᏾ᏁᏌᏟᏴᏟ ᏟᏟ᏾ᏟᏟᏟ ᏟᏬᏢᏟᏞ᏾Ꭴ ᏲᏌᏟᏟᏟᏟᏬᏟᏌᏼᏌ, ᏟᏟᏟᏯᏟᏟᎤᎤᏌ ᎠᎤᏸᏬᏝᏟᏟᎤ ᖃᏟᎴᎧᏟᏟᏢᏬᏟᎤᏟᏟ. ᎠᎤᏟᏟ ᏟᏝᏝ ᏢᏌᖅᏸᎥᏟᏟᏌᖅ ᏟᏟᏟᎧᏟᏢᎴᏟᎧᏟᎤᎥ ᏌᏟᎧᏟᏢᏌᏟᏴᏟ ḈᏟᏟᏟ ᏟᏟᏟᖅᏌᏴᏟᏟ ᎠᎤᏽᏟᏟᎤᏟ, ᎠᎤᏟᏟ ᏝᏌᏌᏟᏟᏟᏟ ᏬᏝᏢᏟᏌᏟᏟᏟᏟᏟᏴᏟᏟ ᏟᎴᏟᎤ ᏟᎤᏟᏌᎤᏟᏟᏟ ḈᎧᏟᏝᏟᏟ ᏟᎤᏟᏌᏴᖅᏝᏟ ᏟᏟᏲᏟᏟᎧᏽ ᏢᏟᏱᏟᏟᏋᏌ ᏌᏟᏯᏟᎤᏟᏟᏴᏟᏟᏟ ᏌᏌᏼᏟᎧᏌᏴᏟᎧᏴᏟ. ᎠᎤᏟᏟᎯᏟ ᎠᎧᏝᏬᏌᏟ ᏢᏟᏟᎤᏟ ᏟᏳᏟᏌᎤᎥ ᏟᏟᏲᏟᏟᏟᏳᏴᏟᏟᏟᏟᏌ ᏢᏝᏟᏟᎤᏌᏟᏟ ᏟᏟᏴᏟᏟᏬᏟᏌᏝᏟᏟᏟᏟᏟᏟᏟᏌᎧᏟᏌ.

ᎠᎤᏟᏟ ᎠᎤᏟᎯᏟᏟ ᏝᏟᏼᏟᎤᏟᏟᏴᏟᎤᏟ ᎤᏟᏢᏟᏟᏟᖅ ᏝᏟᏟᏟ ᏟᎤᏟᏼᏟᏟᏟᎧᎤᏬ ᏟᎤᏟᏟᎧᏬ ᏢᏌᏌᏲᏌᏴᏬᏬ ᏢᏝᏟᏸᏟᏟ ᏝᏟᏴᏟᏟᏲᏝᎧᏈᏟ ᏟᏝᏟᏌᎤᏬᏬᏟᏢᏟ ᏟᏟᖅᏝᏟ.

ᎠᎤᏟᏟ ᎤᎧᏟᏟᎥᏟᏴᏟᏟᏌᏟᏟᏢᏟ ᏟᏋ ᏟᏝᏟᏌᏬᎤᏝ ᏟᏟᎧᏟᏝᏌᏟᏟᏟᏟᏟ, ᖃᏟᎴᏟᏌᎧᏬ ᏌᏒᏟᏟᎥᏌ᎐ ᏝᏟᏲᏟᏬᏟᏟᎧᏟᎤ ᎠᎤᏟᏟᎧᏼᏌᏟ ᏟᏟᎥᎥᏬᏟ ᏟᏝ ᏟᏟᏟᏳᏟᏌᏴᏝᏟᏞᏟᏟᏟ ᏟᏱᏟᏝᏟᏬᏟᏟ ᏟᏟᏬᏌᏟ᎐ᏟᏟᏟᏌᏟᏴᏟᏟᏟᏟᎧ ᏟᏟᏟᎧᏟᏟᏌᏌᏟᎤᏌᏟᏌᏟ ᏟᏟᏟᏟᏟᏟᏸᏟᎧᎥᏟᏴᏟᏬ ᏢᏌᏟᏟ᎐ᏝᏴᏟᏌᏴᏟᏌ ᏟᏟᏟᎧᎤᏬᏴᏟᏟ ᏟᏬᏟᎧᏟᏟᏟᏟ ᏟᏟᏟᏟᏝᏴᏟᏟ ᏟᏝᎧᏟᏟᏟᎧᏟᏝᏟᏌᏴᏟᏟᏟᎤ ᎠᎤᏟᏟᎤᏟᏌᏟᏴᏝᏌ ᏟᎧᏟᏟᎠᎤᏟᏟᏟᏟ.

ᏝᏌᏟᏟᏞᏟᏟ ᏟᏟᏟᏟᏟᏌ ᏟᏟᏝᏟᏯᎥᏬᏌᏟᏴᏟᏟᏟ ᏟᏬᏌᏟᏟᏌᏴᎧ ᏌᏟᏬᏴᏌ ᎠᎤᏟᏴᏝᏬᏟ ᎠᎠᏟᏝᏴᏴᏟ ᎠᏝᏲᏟᏟᖅᏴᏟᏟ ᏢᏌᏌᏟᎠᎤᏟᎧᏟᏝᏴᏌᏟᏟᏟ. ᏟᏟᏝᏝᏟᏴᏟᏬᏌ ᏟᏟᏟᏝᏌᏸᎤ ᏟᏟᏌᏟᎠᏟᏴᏟᏟ ᏟᏟᏱᏟᏝᏴᏟᏲᏌᏟᏟᏟᏌᏴᏟᏟᏟᏴᏬ ᏌᏴᏌ ᏢᏢᏟᏌᏟᏟᏴᏟᏝᏴᏌᏴᎧ ᏢᏝᎤᏢᏌᏟᏴᏌ ᎤᎧᏴᏝᎧ.

ᏢᏱᏟᎥᏟᏟ ᏟᏟᏌᏌᏌᏟᏟᏼᏟᏟᎧᏟᏟ ᏟᏝᏟᎧᏌᏟᏢᏟ ᎠᎤᏟᏱᏝᏟᎧᏬᏟᏟᏟ ᏬᏢᏟᏝᏝᏟᏒᏝᏸᏌᏟ ᏂᏝᏴᏳᏱᎥᏟᏴᏟᎧ ḈᏟᎠ ᏂᏂᏳᏌᏟᏟᏴᎧ ᎧᏟᏝᏟ ᏦᏟᎧᏟᏂ.

Des formes composées de pierres appelées *inuksuit* font partie des plus importants objets créés par les Inuits, les premiers habitants de certaines parties de l'Alaska, de l'Arctique canadien et du Groenland. Le terme *inuksuk* (le singulier d'*inuksuit*) signifie «agir en tant qu'humain». C'est l'extension du mot *Inuk*, qui veut dire *être humain*.

Ces formes composites étaient utilisées comme points d'orientation, à la chasse ou lors des navigations. Elles pouvaient également servir de relais de messagerie. Les Inuits construisaient d'autres formes avec des pierres appelées *innunguait*, ce qui signifie «ressemblant à l'humain». Outre leurs fonctions pratiques, ces constructions possédaient une dimension spirituelle et étaient objet de vénération. Elles pouvaient symboliser le seuil du paysage spirituel des *Inummariit* - les Inuits qui savaient survivre sur la terre conformément à leurs traditions.

Le besoin des *Inummariit* de créer des *inuksuit* était si fort qu'on les retrouve dans les légendes et les contes, dans les dessins que tracent les mouvements des doigts jouant avec une ficelle et dans une constellation du ciel hivernal.

Bon nombre d'Inuits qui ont vécu la plus grande partie de leur vie sur la terre conservent un fort attachement pour les *inuksuit* construits, semble-t-il, par leurs ancêtres. Certains «vieux» *inuksuit* sont mentionnés dans des *Aya-yait*, les chansons de voyage transmises de génération en génération pour aider les voyageurs à se rappeler des directions à prendre lors des longs voyages. Souvent, ces vieux *inuksuit* sont tout simplement vénérés pour ce qu'ils représentent. De nos jours encore, la vue d'un *inuksuk* familier dans le paysage apaise ceux qui sont loin de leur foyer.

Qu'ils représentent leur créateur, qu'ils aient agi en son nom ou qu'ils soient l'objet de vénération, les *inuksuit*, créés de l'arrangement d'un nombre infini de pierres, ont constitué des aides et des messages. Ils faisaient partie intégrante du langage des chasseurs et constituent une signature indélébile sur le paysage de l'Arctique.

Voyagez dans le temps et explorez en profondeur les *inuksuit* et leur signification. Lisez *Inuksuit: Silent Messengers of the North*, de Norman Hallendy.

Entre los objetos más importantes creados por los inuits que fueron el primer pueblo que habitó partes de Alaska, el Ártico canadiense y Groenlandia se encuentran figuras hechas de piedra llamadas *inuksuit*. El término *inuksuk* (el singular de *inuksuit*) quiere decir "actuar en calidad de humano". Es una extensión de *inuk* que significa "un ser humano".

Estas figuras de piedra fueron colocadas en los paisajes temporales y espirituales. Entre muchas otras funciones prácticas eran empleadas como instrumentos de caza y navegación, indicadores de coordenadas, indicadores y centros de mensajes. Los inuits construyeron también figuras de piedra llamadas *innunguait* que significa "a semejanza de un ser humano". Además de sus funciones terrenales, ciertas figuras tipo *inuksuk* tenían connotaciones espirituales, y eran objeto de veneración, señalando con frecuencia el comienzo del paisaje espiritual del *inummariit,* los inuit que sabían cómo sobrevivir en la tierra viviendo a sus modos tradicionales.

El deseo de los *inummariit* de crear *inuksuits* era tan urgente que éstas aparecen no sólo en el paisaje terrenal sino también en historias y leyendas, en figuras que surgen de los movimientos de los dedos que juegan juegos de cuerdas; y en una constelación de cielo invernal.

Varios inuits que vivieron la mayor parte de sus vidas en la tierra guardan un fuerte apego a las *inuksuit* que suponen fueron construidas por sus ancestros. Algunas de las "viejas" *inuksuit* son mencionadas en las *Aya-yait*, las canciones de viaje transmitidas de generación en generación para ayudar a viajeros y viajeras a recordar una serie de indicaciones para hacer viajes largos. Con frecuencia se veneran estas viejas *inuksuit* sin que importe cuál sea su función. Aún hoy la aparición en el paisaje de *inuksuit* familiares es una imagen que recibimos con agrado cuando estamos lejos de casa.

Ya fuera que simbolizaran a su constructor o constructora, que actuaran en calidad de él o ella, o que fueran objetos de veneración, las *inuksuit* funcionaban como ayudantes y mensajes creados por una disposición infinita de piedras. Eran una parte integral del lenguaje de los cazadores y perduran como firmas indelebles en el paisaje ártico.

Para un viaje a través del tiempo y una exploración en profundidad de las *inuksuit* y su significado, se puede leer *Inuksuit: Silent Messengers of the North* de Norman Hallendy.

*Inuksuit*, aus Steinen zusammengesetzte Figuren, gehören zu den wichtigsten Schöpfungen der Inuit, der ersten Menschen, die Teile von Alaska, der kanadischen Arktis und Grönlands besiedelten. Das Wort *inuksuk* (die Singularform von *inuksuit*) bedeutet "als Mensch handeln" und ist eine Erweiterung von *Inuk*, was soviel wie "ein menschliches Wesen" bedeutet.

Diese Steinfiguren wurden sowohl in die reale als auch in die spirituelle Landschaft gestellt. Sie hatten viele praktische Verwendungszwecke: Sie waren Hilfsmittel bei der Jagd und der Navigation, sie waren Koordinaten, Wegweiser und Nachrichtenzentren. Die Inuit schufen außerdem eine Art von Steinfigur, die als *innunguait* bezeichnet wird; das bedeutet "nach dem Bildnis eines Menschen". Neben ihren irdischen Funktionen hatten gewisse *inuksuk*-ähnliche Figuren eine spirituelle Bedeutung und waren Gegenstand der Verehrung. Oft markierten sie die Schwelle zur spirituellen Landschaft der *Inummariit* der Inuit, die dank ihrer hergebrachten Lebensweise wußten, wie man im hohen Norden überlebt.

Der Drang der *Inummariit* zur Schaffung von *inuksuit* war so überwältigend, daß die Figuren nicht nur in der sichtbaren Landschaft zu finden sind, sondern auch in Legenden und Geschichten auftauchen sowie in Figuren, die aus Fingerbewegungen bei Bindfadenspielen entstehen, oder in Sternbildern am winterlichen Himmel.

Viele Inuit, die den größten Teil ihres Lebens im hohen Norden zugebracht haben, behalten eine starke Bindung an *inuksuit*, von denen sie glauben, daß ihre Vorfahren sie geschaffen haben. Einige der "alten" *inuksuit* finden in den *Aya yait* Erwähnung, den Liedern für Reisende, die von jeder Generation an die nächste weitergegeben werden und Reisenden helfen sollen, auf langen Strecken Beschreibungen der Route im Gedächtnis zu behalten. Oft werden diese alten *inuksuit* ohne Rücksicht auf ihre Funktion verehrt. Bis heute sind für jemanden, der weit von zu Hause weg ist, vertraute *inuksuit* in der Landschaft ein willkommener Anblick.

Ob sie ihren Erbauer symbolisierten, ob sie als Menschen handelten oder ob sie Gegenstand der Verehrung waren - *inuksuit*, diese Gebilde aus einer unendlichen Anordnung von Steinen, wirkten als Helfer und als Darstellung von Nachrichten. Sie waren ein wesentlicher Bestandteil der Jägersprache und stehen bis heute als unauslöschliche Zeichen in der Landschaft der Arktis.

Wer eine Reise durch vergangene Zeiten und eine wunderbare Erkundungsfahrt zu *inuksuit* in all ihrer Bedeutung unternehmen will, sollte das Buch *Inuksuit: Silent Messengers of the North* von Norman Hallendy.

## 北極の無言のメッセンジャー

アラスカ、カナダ極圏、グリーンランドの先住民であるイヌイットにとってはイヌックサックと呼ばれる石像は最も貴重である。イヌックサックという名称は"イヌック"（『人間』）から起源し、『人間としての能力を持つ』と意味する。

これらの石像は実際のと精神的、霊的な背景と両方に位置づける。実用的な機能も持ち、航海や狩の目印、座標点、伝言版などに使われた。イヌイットはイヌンガーク（『人間的な様態』）と呼ばれる石像も造る。実用以外には、イヌックサックなどの像は崇拝的な意味を持ち、イヌマリット（伝統的な生き方を知る先住民）の精神的な成長過程の始まりを示す。

イヌックサックを造る願望の強さは、イヌックサックが歴史や伝説、綾取りの型、冬空の星座などに頻繁に出てくることで明白である。

現在でも土地に依存する生き方をしているイヌイットは、先祖が建てたと信じて、イヌックサックに激しい愛着を持っている。長旅中の道を覚えるために代々語り継がれた歌『アヤ-ヤイト』に古代のイヌックサックが現れる。
これらの古いイヌックサックは、その機能に関係なく、崇拝されている。今日でも、里から遠く離れているときに見慣れたイヌックサックに出会うのは、ほっとするものだ。

作者を象徴するか、作者の代わりをするか、崇拝のためか、無限な石の組み合わせは目的以外でもメッセージを残した。イヌックサックは、猟師の言語の貴重な一部であり、署名として極圏の地表に永久に残るものである。

更に深いイヌックサックの意義を時間を越えて楽しむには、Norman Hallendy
著の　『イヌックサック－沈黙の伝達子』をお読みください。

## ACKNOWLEDGEMENTS

I would like to sincerely thank the Inuit elders and others in the Arctic who enrich my life in many ways. With some, I travelled to places that had to be seen to be believed; with others, I travelled to places that had to be believed to be seen. The following is a recognition of those who, either directly or in some other manner, helped me to understand inuksuit, objects of veneration and the very land upon which we exist.

Baker Lake–Qamanittuaq ("far inland"): Martha Tiktaq Anautalik, Myra Kukiijaut, Arngna'naa, Norman Atangala, John Killalark, Lucy Kownak, Margaret Narkjangerk, John Nukik, Barnabus Perjoar, Hugh Tuluqtuq and Elizabeth Tunnuq.

Cape Dorset–Kinngait ("high mountains"): Pitseolak Ashoona,* Osuitok Ipeelee, Itulu Itidlouie, Kenojuak Asheavak, Ottochie,* Issuhungitok Qiatsuq Pootoogook,* Paulassie Pootoogook, Pudlat Pootoogook,* Pudlo Pudlat,* Osutsiak Pudlat,* Simeonie Quppapik,* Pauta Saila, Pitaloosie Saila and Pauloosie Tulugak.*

Eskimo Point–Arviat ("place of the bowhead whale"): Margaret Aniksak,* Peter Aningaat, John Arnalugjuaq, Henry Ishuanik, Elizabeth Issakiak, James Konek, Andy Mumgark, Luke Suluk, Peter Suwaksiork, Leo Ulayok and Silas Ulinaumi.

Ulukhaktok (Holman)—Ulukhaqtuuq ("where material to make ulus is found"): Wallace Goose.*

Pangnirtung–Pangnirtuuq ("place of fat caribou"): Jim Killabuk.*

Pelly Bay–Kugaaruk ("place of the little river or stream"): Three very old hunters.*

Pond Inlet–Mittimatalik/Tununiq ("place of Mittima's grave"): Simon Akpaleeapik.

Povungnituk–Puvirniqtuq ("where there is the smell of aged meat"): Tomassi Qumaq.*

Rankin Inlet–Kangiq&iniq ("the great inlet"): Rev. Armand Tagoona.*

SPECIALISTS WHO PROVIDED ASSISTANCE:

GUIDES

Baker Lake–Qamanittuaq: John Nukik.

Cape Dorset–Kinngait: Itulu Itidlouie, Jimmy Manning, Pingwortuk,* Marc Pitseolak, Peter Pitseolak,* Lukta Qiatsuq,* and David Saila.

Eskimo Point–Arviat: Phillp Tasseor.

Rankin Inlet–Kangiq&iniq: Henry Kablalik.

ILLUSTRATORS

Baker Lake–Qamanittuaq: Ruth Qaulluarjuk.

Cape Dorset–Kinngait: Osutsiak Pudlat,* Pudlo Pudlat,* Simeonie Quppapik* and
    Pitaloosie Saila.

INTERPRETERS

Cape Dorset–Kinngait: Pallaya Ezekiel, Salomonie Jaw, Annie Manning, Jeannie
    Manning, Nina Manning, Leetia Parr, Pia Pootoogook and Mukshowya Niviaqsi.

Pelly Bay– Kugaaruk: Dolorosa Nartok.

LINGUISTS

Igloolik and Ottawa: Deborah Evaluarjuk.

REFERENCES

Eskimo Point–Arviat: Peter Komak, Eric Andee, Donald Suluk and Aniksarauyak.

Povungnituk–Puvirniqtuq: Tumassi Qumaq.*

RESEARCHERS

Baker Lake and Ottawa: Sally Qimmiu'arq-Webster.

Toronto: Linda Morita.

* now deceased

I express sincere thanks to the Polar Continental Shelf Project, which made it possible to explore remote and important areas with my Inuit elders. Proulx Imaging Labs of Ottawa has generously assisted in the technical aspects of my documentary work, and the Kinngait Cooperative and the Hamlet of Cape Dorset have supported my work for many years. I am particularly grateful for the opportunity to be in the field with Dr. Marc St-Onge, senior scientist of the Geological Survey of Canada. I am most grateful to Diana Cousens who keeps "the farm" running and some semblance of order in my life, wherever I may be. My friend Peter Irniq, former Commisioner of Nunavut, continues to provide valuable advice. Dan Utting and Sigurour Magnusson generously provided rare images from India and Iceland. There is a very fine person tucked away in the National Defence Image Library in Ottawa by the name of Dennis Mah, who was tireless in seeking out the images from DND photo archives. And finally, I am thankful to have had the opportunity to work with Scott Steedman, a brilliant editor; George Vaitkunas, one of Canada's best book designers; the very skillful and meticulous Eve Rickert; and my friend and publisher Scott McIntyre of Douglas & McIntyre. Masumi Abe at the University of British Columbia generously assisted with proofreading the Japanese text.

The Inuktitut terms used in this book were given to me by the Sikusiilarmiut, the elders of the Cape Dorset area. Many of these elders still used certain archaic terms as late as the early 1960s. In the early days, I often wrote out words phonetically, as a standard orthography was still in development. I considered having the entire collection of Inuktitut words and expressions in this and other manuscripts vetted and, where necessary, altered to conform to present-day usage. My Inuit mentors encouraged me to leave them be, however, as the words accurately render the meaning ascribed to them. Together with the elders and the brilliant Manning sisters—Annie, Nina and Jeannie—and Leetia Parr, it was possible to construct a dictionary unique to the Sikusiilaq (Foxe Peninsula) area.

## FURTHER READING

To learn more about inuksuit and related objects and places, search out these other works by Norman Hallendy:

1985
Reflections Shades and Shadows, in *Collected Papers on the Human History of the Northwest Territories*, Occasional Paper no. 1, Yellowknife, Prince of Wales Northern Heritage Centre: 31-32

1990
*Methodology for Studying Inuksuit of Northern Quebec*, unpublished document consulted at the Avataq Cultural Institute, Montreal

1992
Inuksuit: Semalithic Figures Constructed in the Canadian Arctic, Paper presented at the 25th Annual Meeting of the Canadian Archaeological Association, London, Ontario

1994
Inuksuit: Threads of Arctic Prehistory: Papers in Honour of William E. Taylor Jr. Mercury Series, Canadian Museum of Civilization 1994

1997
The Silent Messengers, *Equinox*, 85: 36-46.

2000
*Inuksuit: Silent Messengers of the Arctic*, Vancouver, Douglas & McIntyre.

2005
Silent Messengers, a documentary film produced by Picture Plant and the National Film Board of Canada

Visit the interactive site of the Tukilik Foundation at http://www.tukilik.org

http://www.civilization.ca/archeo/inuksuit/inukbioe.html

http://gsc.nrcan.gc.ca/baffin4d/bio/hallendy_e.php

http://www.ammsa.com/bookreviews/Messenger-review.html

Norman Hallendy's experiences are as diverse as his interests. A graduate of the Ontario College of Art in the field of industrial design, he carried out graduate studies in Sweden, Italy and Switzerland. He then spent his entire working career as a senior civil servant for the Government of Canada, contributing directly to the formulation of public policy aimed at improving conditions for the Inuit throughout the North. He was also the senior vice-president of one of Canada's largest Crown corporations, where he exerted much influence in improving housing policies and delivery programs. His responsibilities while working in the Department of Northern Affairs and the National Film Board of Canada allowed him to contribute to the development and worldwide recognition of Inuit art.

Norman Hallendy has received the Rowney Prize, the Canada Council Explorations Grant, the Eaton Scholarship, the Royal Canadian Geographical Society Fraser Lectureship, the Royal Canadian Geographical Society Gold Medal and, most recently, the Royal Scottish Geographical Society Mungo Park Medal for his outstanding contribution to ethnogeography. He has given lectures at numerous universities in Canada, the United States and beyond, including both Cambridge and Oxford. When not in the Arctic, he lives in the village of Carp, about fifty-five kilometres outside of Ottawa, Canada. To his Inuit friends he is simply known as *Apirsuqti*, "the inquisitive one."